The Concerned Photographer 2

"For me, the photographer is a witness. His job is to record real events rather than to stage or create something in front of the camera."

Marc Riboud

"Everything made by human hands looks terrible under magnification —crude, rough, and unsymmetrical. But in nature every bit of life is lovely. The more magnification that we can use, the more details are brought out, perfectly formed."

Roman Vishniac

"Most of my photographs are compassionate, gentle, and personal. They tend to let the viewer see himself. They tend not to preach. And they tend not to pose as art."

Bruce Davidson

"I want my children and children's children to be able to look at my pictures and know what my world was like. Even if it only helps a little bit toward this understanding, then I've done my job and done it well."

Gordon Parks

"…and man is really an outcome of many, many rehearsals. You can find a tree within us as much as you can find a human figure in the snow. In order to have a consciousness that can appreciate nature you have to create man."

Ernst Haas

"It is sometimes good for man to look intently at nature."

Hiroshi Hamaya

"Someone may have been killed by the wayside and his body is rotting away and nobody cares that it was a human being and it was a person —a living person. I care, and I am going to photograph it—as horrible as it looks, I'm going to photograph it."

Donald McCullin

"…and each time I pressed the shutter release it was a shouted condemnation hurled with the hope that the picture might survive through the years, with the hope that they might echo through the minds of men in the future—causing them caution and remembrance and realization."

W. Eugene Smith

2

the concerned photographer

the photographs of

MARC RIBOUD
DR. ROMAN VISHNIAC
BRUCE DAVIDSON
GORDON PARKS
ERNST HAAS
HIROSHI HAMAYA
DONALD McCULLIN
W. EUGENE SMITH

Editor
CORNELL CAPA

GROSSMAN PUBLISHERS, NEW YORK 1972
in cooperation with The International Fund for Concerned Photography, Inc.
ICp

FIRST PUBLISHED IN 1972
IN A HARDBOUND AND PAPERBOUND EDITION BY
GROSSMAN PUBLISHERS
625 MADISON AVENUE, NEW YORK, N.Y. 10022

PUBLISHED SIMULTANEOUSLY IN CANADA
BY FITZHENRY AND WHITESIDE, LTD.

SBN 670-23556-3 (HARDBOUND)
670-23557-1 (PAPERBOUND)

LIBRARY OF CONGRESS CATALOGUE CARD NUMBER: 68-31898

PRINTED AND BOUND IN FRANCE

Editor
CORNELL CAPA

Associate Editor and Text by
MICHAEL EDELSON

Editorial Assistants
REGINA FIORITO, TERI GERSHON, YVONNE KALMUS

Design by
ARNOLD SKOLNICK

Acknowledgments

Grateful acknowledgment is made to Sheila Turner and Scholastic Magazines, Inc., for allowing us to use some of the material from *Images of Man: Scholastic's Concerned Photographer Program,* an audiovisual library series on the work of Bruce Davidson, Donald McCullin, W. Eugene Smith, and Cornell Capa, produced in collaboration with ICP.

The Fund would like to express its gratitude and thanks to the many people and organizations through whose cooperation we were able to obtain the work of the eight photographers: Grace Blake and LIFE magazine for the work of Gordon Parks; Magnum Photos, Inc., for the work of Bruce Davidson and Marc Riboud; the London SUNDAY TIMES for the work of Donald McCullin; Hiroji Kubota for the work of Hiroshi Hamaya; Edith Vishniac for the work of Dr. Roman Vishniac; Aileen M. Smith and Leslie Teicholz for the work of W. Eugene Smith; and Marina Filicori for the work of Ernst Haas.

Special thanks are due to Teddy Kollek, Mayor of Jerusalem, and Elisheva Cohen, Director of the Israel Museum, where *The Concerned Photographer 2* exhibit will have its first showing in September 1973.

Introduction

Only five years ago, in October 1967, *The Concerned Photographer* exhibit first opened, presenting an antidote to the then-accepted bland notion equating the "objectivity" of a photographic image with dispassionate neutrality. The work of the six photographers (Werner Bischof, Robert Capa, Leonard Freed, André Kertész, David Seymour ["Chim"], and Dan Weiner) selected for this exhibit demonstrated, instead, the intense empathy and involvement of each with his fellowman and the world in which he lived. It struck a responsive chord in all who saw it.

The Concerned Photographer exhibit and The International Fund for Concerned Photography was conceived during a decade of tumultuous change in the arts, in the communications media—in the very quality of life in our world as a whole. It came at a time when the public had had its fill of being passive observers to the indignities that the sixties had brought upon them. With television firmly established as the major news medium, causing the subsequent withering away of mass-circulation picture magazines (which, in turn, resulted in a significant loss of support to photographic activities), the emergence and existence of the Fund became essential. Its declared goal "to encourage and assist photographers of all ages and nationalities who are vitally concerned with their times," and its aim "not only to find and help new talent, but also to uncover and preserve valuable and forgotten archives and to present such work to the public," made inevitable the Fund's role as a cohesive force in the creation of believable "visual documents."

Barely a month after the opening of *The Concerned Photographer,* the "Concerned Democrats" were born in support of Senator Eugene McCarthy. Then followed the deluge—"Concerned Citizens" for every conceivable cause united, and it is safe to predict that the sixties will be remembered as the "decade of concern."

Humanism in photography has a long and noble tradition—from Matthew Brady, Jacob Riis, Dorothea Lange, and a host of others, to those contemporary practitioners who use their cameras as a tool of social conscience and a means of expressing their reverence and affirmation of life. Lewis W. Hine, an early humanitarian with a camera, expressed it well when he stated: "There were two things I wanted to do. I wanted to show the things that had to be corrected. I wanted to show the things that had to be appreciated." More recently another photographic giant, Edward Steichen, said (on the occasion of his ninetieth birthday): "When I first became interested in photography...my idea was to have it recognized as one of the fine arts. Today I don't give a hoot in hell about that. The mission of photography is to explain man to man and each man to himself. And that is the most complicated thing on earth and also as naïve as a tender plant."

No day passes without someone questioning the power of photographs to cause change. As a photographer, I have my own positive opinion. However, in response, simply consider the role of the written word, which has had a longer track record. Has *it* managed to cause change? Images at their passionate and truthful best are as powerful as words ever can be. If they alone cannot bring change, they can, at least, provide an undistorted mirror of man's actions, thereby sharpening human awareness and awakening conscience.

There remains no doubt that we are living in a visual world and far less doubt about the orientation of the future. The individuality and integrity of the photographer, as well as the quality and credibility of his images, are vital to the creation of a visual history of our time—the first century to be documented with the visual commentary of all those who have discovered that the camera can express their most deeply felt convictions.

Photography has earned its original appellation (from the Greek "to write with light"). There is, and will be, "visual writing," which will include all kinds, from the most mundane and commercial to the unique artistic creations and documentary/commentary depictions of the world in which we live. The latter two can be most readily characterized as "concerned photography"—photography that, in Steichen's words, has a mission "to explain man to man and each man to himself." This is the role to which the Fund dedicates itself.

Considering the extremely limited number of creative institutions or groups presently engaged in producing and presenting the kinds of visual materials our programs provide, the Fund is fulfilling, at this crucial time, a most needed and important artistic-educational-social-historical function. Each of our projects serves to assist photographers in a direct way by providing them opportunity to work where there is usually no commercial support—work that would not get done otherwise or appear before a viewing public. To date, these projects have been supported in part by small grants from foundations and the New York State Council on the Arts and through individual contributions.

It has been a difficult but productive and soul-filling five years as the Fund's chronology in the appendix demonstrates. Our direct and indirect influence on the role and direction of contemporary photography has become clearly visible. As another milepost of our efforts, we are proud to present this volume and the exhibit upon which it is based, which will make its appearance in Jerusalem in 1973 at the first photographic *Triennale* dedicated to "concerned photography."

Cornell Capa

Preface

Just what *is* a concerned photographer? Is he simply a social worker with cameras instead of case files? Is he nothing more than a bleeding heart with Kodachrome II? The simple answer is no, but that requires some explanation since the many who think they know what constitutes a concerned photographer are usually only half right.

One half of the concerned photographer is Donald McCullin recording man's inhumanity to man for posterity; but the other half is Ernst Haas discovering for both himself and us the beauty of the human nude in the snows of Aspen. Dr. Roman Vishniac combines both these qualities in his compassionate historic photographs of Eastern European Jewish ghetto life before the holocaust and in his photographic voyages into the previously unrevealed beauties of microscopic life. The photojournalistic reporting of Marc Riboud soars beyond the level of the immediate present when one gazes at the overwhelming landscapes taken in China that show so clearly how the revolutionized Chinese are still part of the land as ever before: transcendental visual commentary that remains steadfastly valid and beautiful. And yet how differently Hiroshi Hamaya demonstrates the very same union between man and environment, only here the land is Japan and the never-cut umbilical cord is Japanese. Gordon Parks's concern is not only for his own black people: through his images he demonstrates the hope that the white man will understand what it means to be "born black." While Parks speaks as a black man, Bruce Davidson communicates as a white photographer who is capable of finding strong beauty in the ghetto life of New York's East 100th Street. And, finally, W. Eugene Smith, who painfully admits that "my camera, my intentions stopped no man from falling. Nor

did they aid him after he had fallen. It could be said that photographs be damned for they bound no wounds." Out of this seemingly bitter defeat, Smith, phoenix-like, finds the answer for himself and so many others. "Yet, I reasoned, if my photographs could cause compassionate horror within the viewer, they might also prod the conscience of that viewer into taking action." And to Smith, as with all photographers in this book, that action is the very affirmation of life itself.

The concern for life is the bond that brings these eight photographers together. But it is not just the beautiful mysteries of life, but also its ugly and equally mysterious qualities that spur a man to risk his life, his very existence, to capture blatant horror so that others may realize what it all means to him, the one behind the camera, who went through it all simply to bring it back alive, if in image only. War is glamorous; sitting behind a microscope or huddling in freezing cold is less so, but the rewards for both photographer and viewer enrich all who touch the magic ensnared by the machine that traps life. Maybe a greater understanding of the concerned photographer is possible if one considers the photographer's camera a life trap, a device for ensnaring those qualities we recall but hardly recognize as they go on before us even if we be the participants.

Therefore, this book, THE CONCERNED PHOTOGRAPHER 2, is a trophy room filled with a collection of life traps of these eight masters, eight experts, eight vulnerable human beings who are extraordinarily sensitized to the point of being "concerned photographers." And so are others who passionately demonstrate their affirmation of life in all of its forms, manifestations, and mysteries with their very own life traps.

<div align="right">
Michael Edelson

Associate Editor
</div>

"The mission of photography is to explain man to man and each man to himself."
—Edward Steichen

Marc Riboud

"To understand and appreciate Riboud's aims, one need only review the subjects he has chosen to photograph. Once examined, a definite pattern takes shape indicating that here is a man who is concerned with people, their unique portion of the earth, and their continually intense interaction upon each other." —Charles R. Reynolds, Jr.

Riboud, as so many photographers before, came to the camera by chance. In his case, he inherited an old Leica from his father. Born in Lyons, France, in 1923, Riboud already was a working industrial engineer when he started to shoot picture stories when the chance arose. At one point during this period, he took a week off in order to finish a story. He never returned to his engineering job. "I'm still on that leave of absence," Riboud jokingly remarks. In 1950 Riboud met Henri Cartier-Bresson and showed him his work. Cartier-Bresson then invited Riboud to join Magnum Photos. Now based in Paris, Riboud spends much of his time working abroad. He is, for example, one of the few Western photographers who has been permitted to photograph extensively in mainland China, and he has gone there three times—1957, 1965, and 1971. His book, THE THREE BANNERS OF CHINA, provides the viewer with the essential Riboud: his photographic style, his photographic philosophy, and his photographic purposes. Throughout the book, and this also goes for most of his work, one finds Riboud realizing man within his environment—the violence and the peace—and the eternal interplay between both. Man may tame the soil but he is forever dependent upon it and what it can and cannot give. Be it a group of strollers on the Great Wall near Peking or Moslem soldiers in deep evening prayer, Riboud locates those essential elements that make each of us unique unto ourselves and make countries different from each other. And yet, Riboud, through his images, shows that permeating all these differences there lies that basic oneness...we all do the same things, only in possibly different ways.

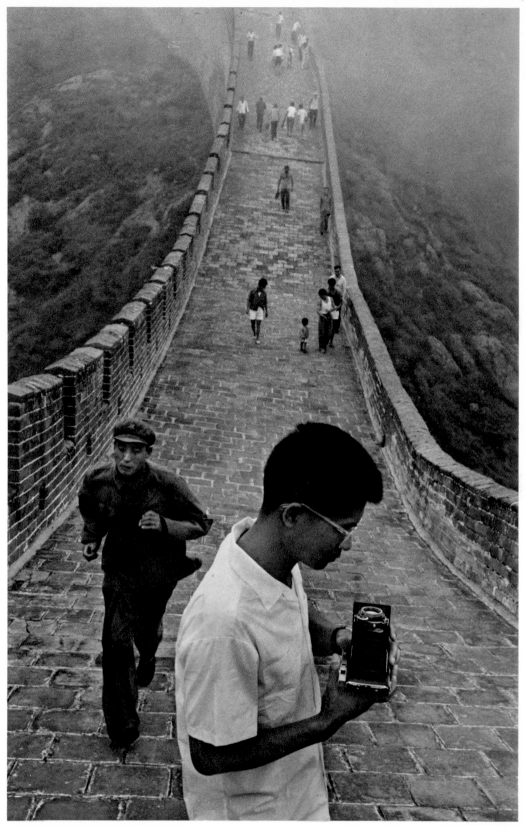

China, 1971

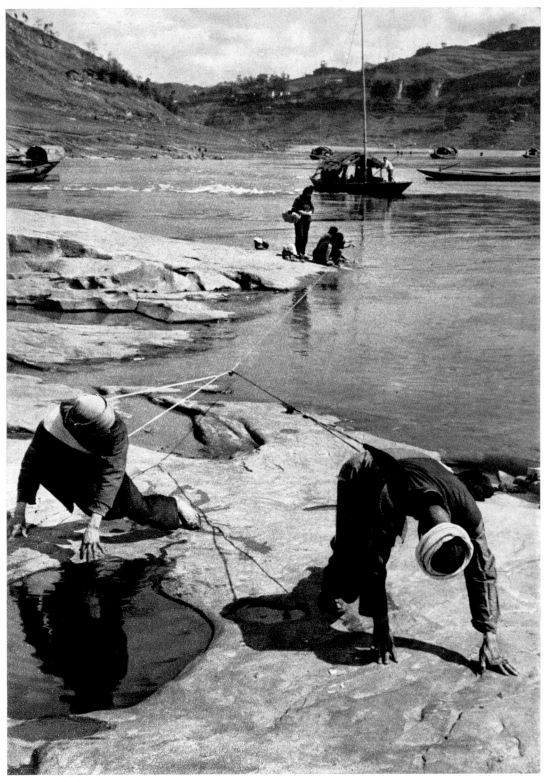

China, 1965

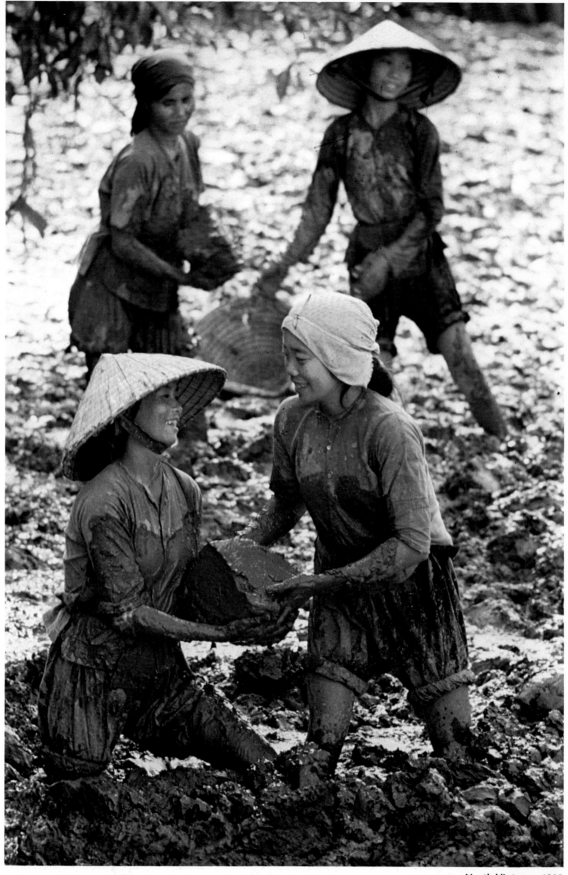

North Vietnam, 1968

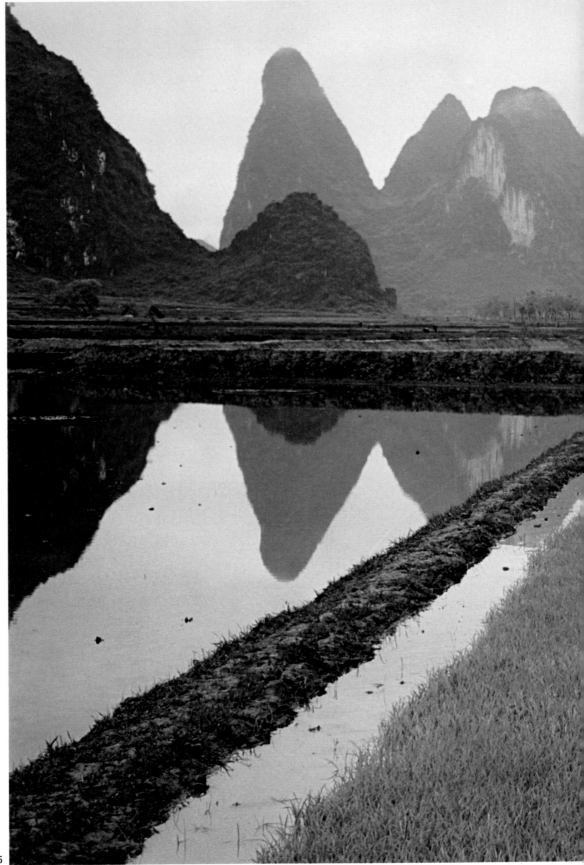

China, 1965

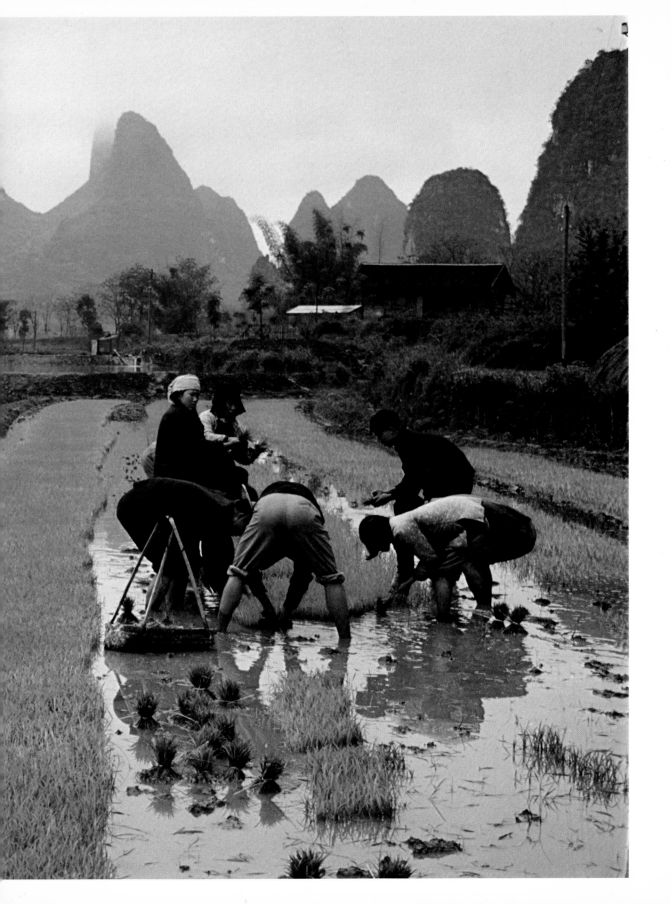

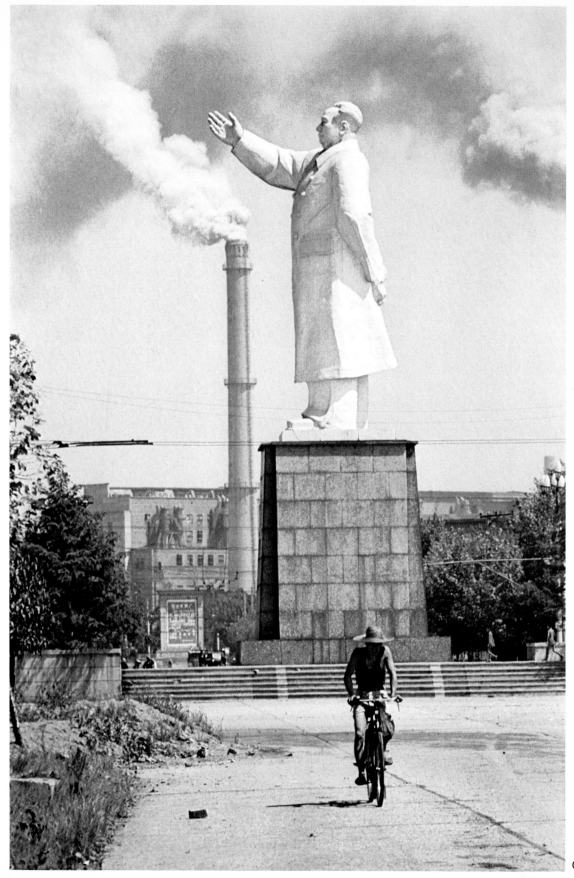

China, 197

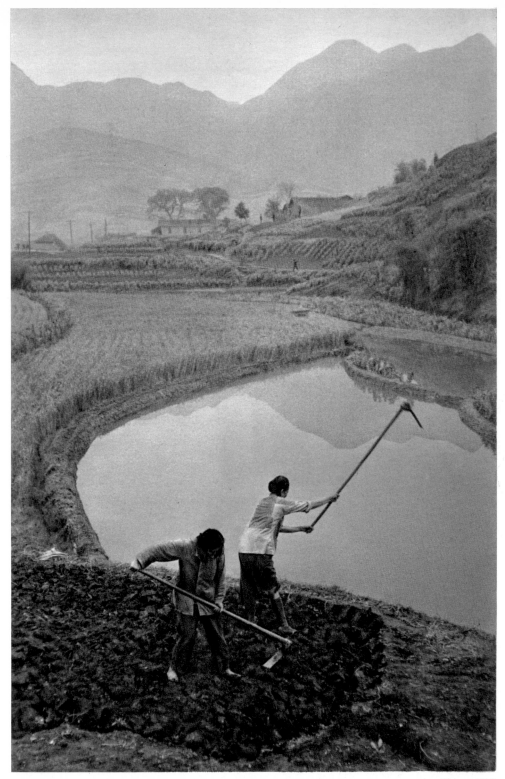

China, 1957

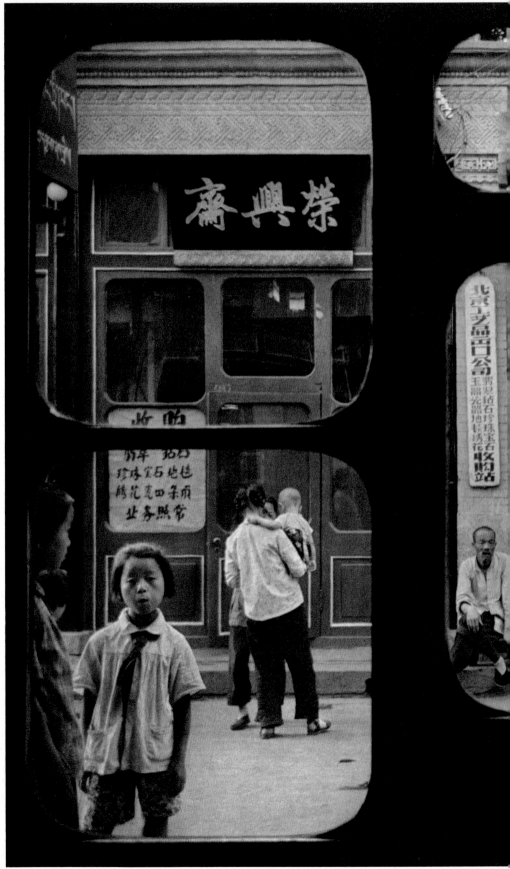

Peking, China, 1965

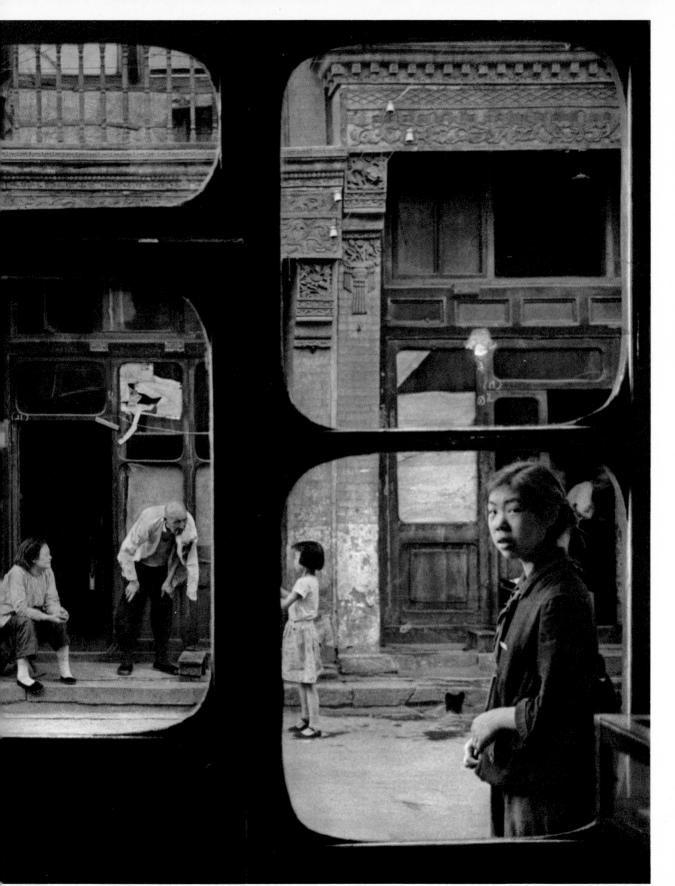

Peking, China, 1971

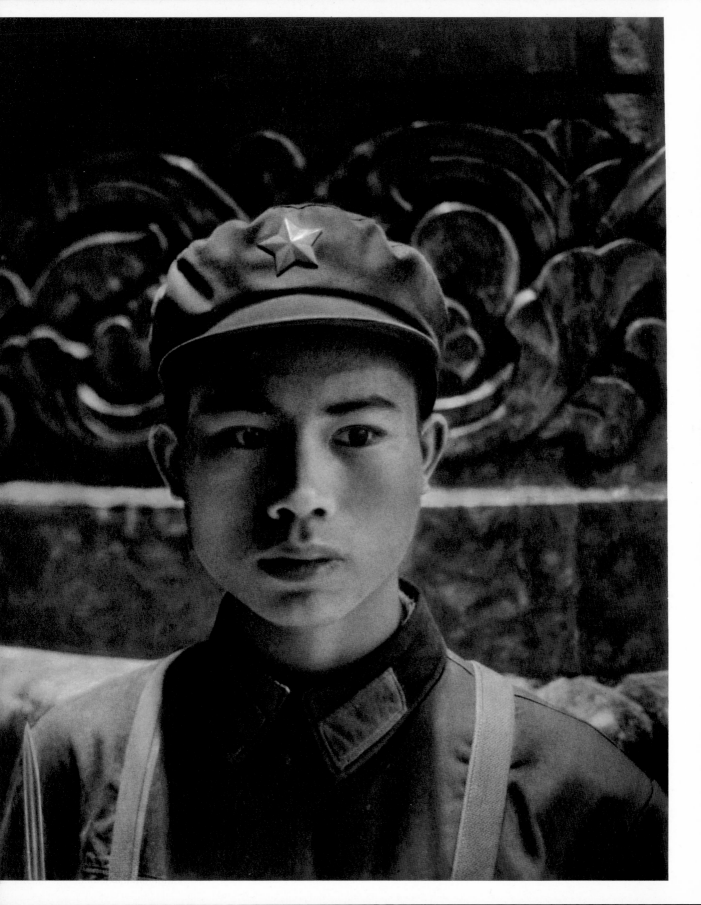

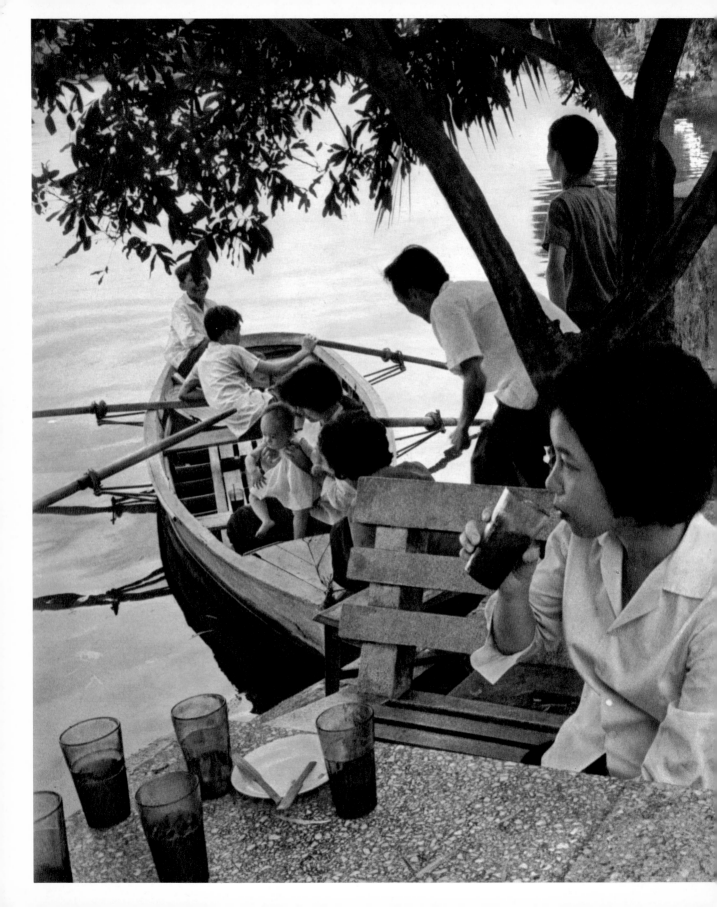

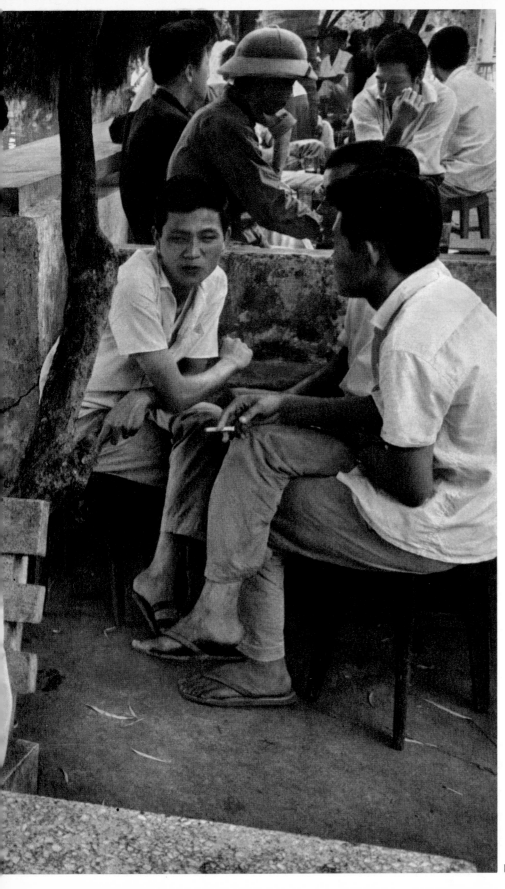

Hanoi, North Vietnam, 1968

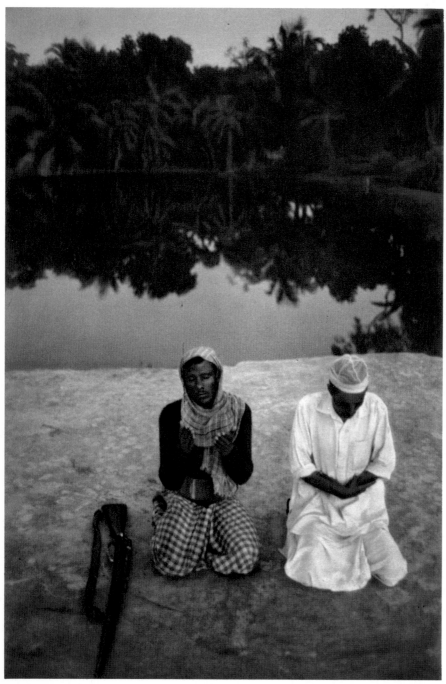

Bangladesh, 1971

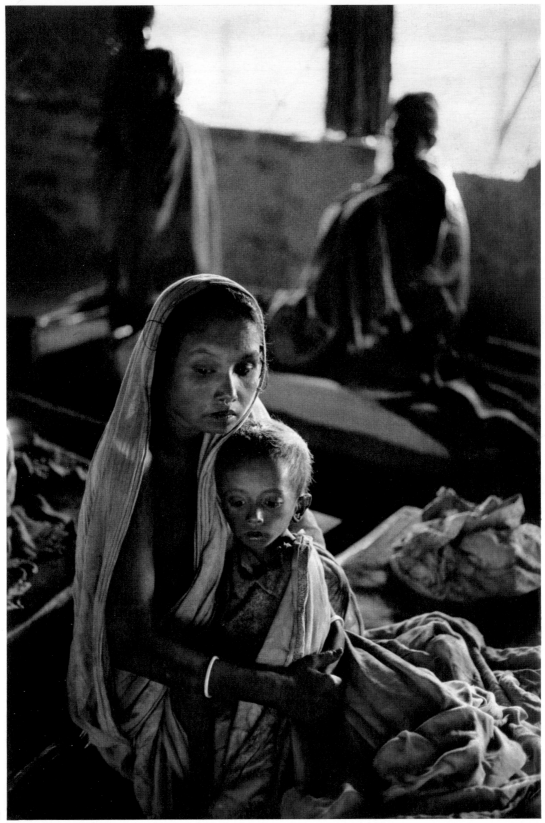

Bangladesh, 1971

Dr. Roman Vishniac

"...the relationship of Dr. Roman Vishniac and the many worlds around him: the big ones and the small ones; the pretty ones and the ugly ones; the obvious ones and the deeply hidden ones that only a camera and a lens can uncover for they are invisible to the naked mind and eye of man."
—**Michael Edelson**

Born in the last of the nineteenth century (1897), Dr. Roman Vishniac's concepts and thoughts of today strike one as being viable in the future of the twenty-first century. Vishniac would never claim such longevity since his training as a doctor and biologist has taught him that what is true today may be untrue only tomorrow. But, at the same time, his other degree in oriental art has made him realize that beauty does last through centuries despite man and time's wear and tear. What might otherwise be a disastrous confrontation waged between a scientist and artist provides, when fought within the mind of Vishniac, a unique blending that is comparable to those exalted men of the Renaissance. For in Vishniac one finds the pragmatic examining eye of the scientist and the loving examining eye of the artist—a grasp of our universe in terms that begin to make sense of life's jungle-like jumble. Vishniac has traveled those unmarked paths—caught in Germany as a student with the outbreak of World War I; escaping from the Soviet Union in 1920, leaving all possessions behind; re-establishing a new life in Berlin to be lost once again as he wisely fled to America via Vichy France in 1940; starting anew in an unappreciative society that was growing resentful of newly landed refugees. Amidst this torrent of confusion and holocaust, Vishniac's mind finds reason and beauty; but do not mistake him for any Pollyanna: he already knew firsthand madness and horror that spurred him to photograph the Jews of Eastern Europe—because *he* believed Hitler! Most importantly, he searches for and finds the essence of the world and man who inhabits it. These are the concerns of Roman Vishniac.

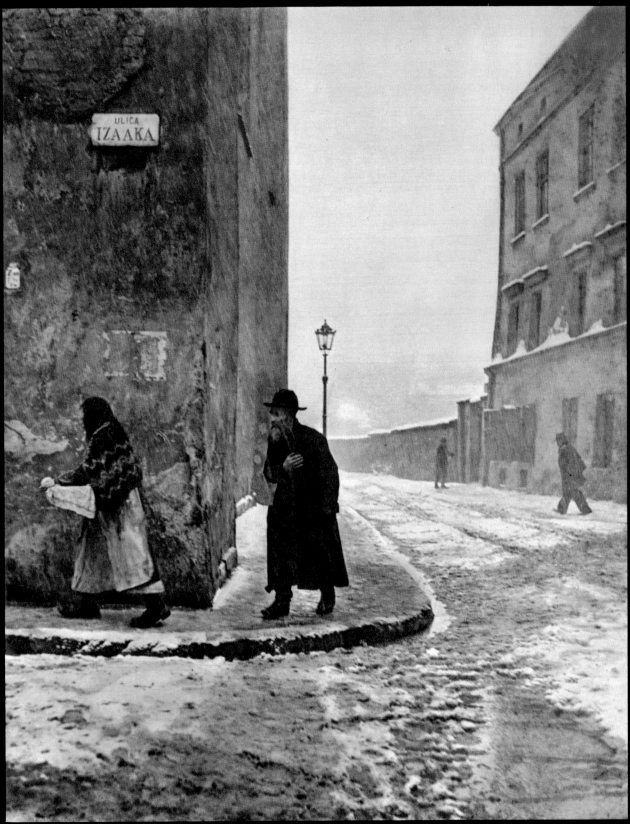

Cracow, Poland, 1939

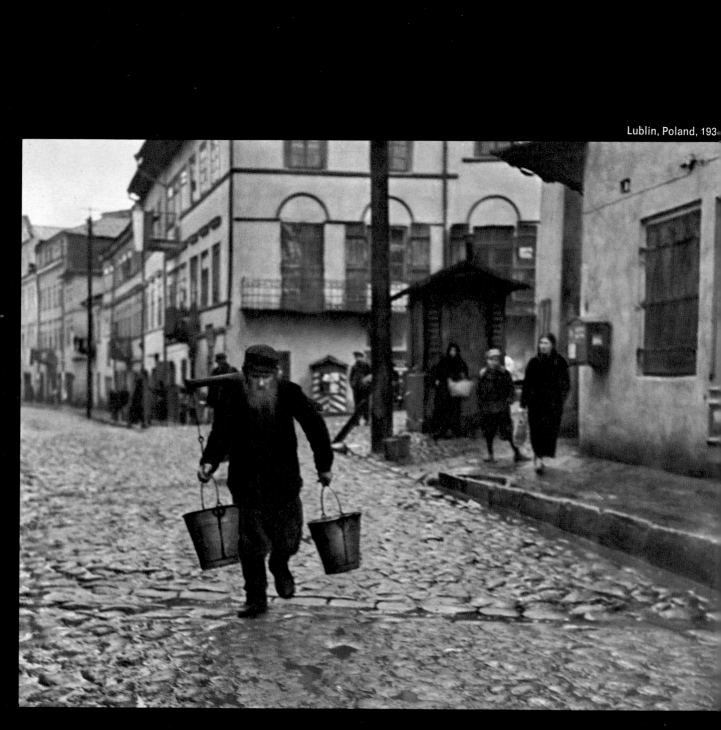

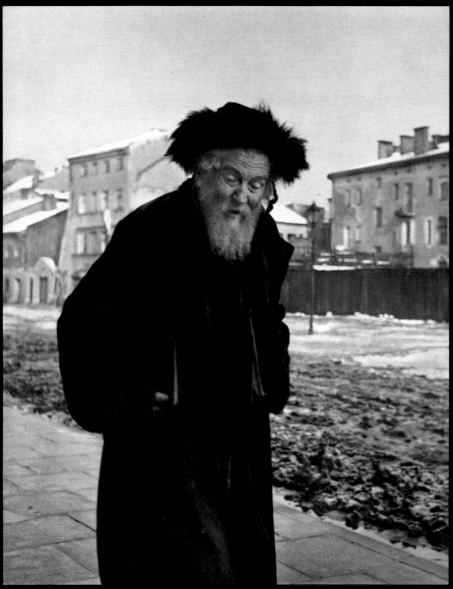

Cracow, Poland, 1937

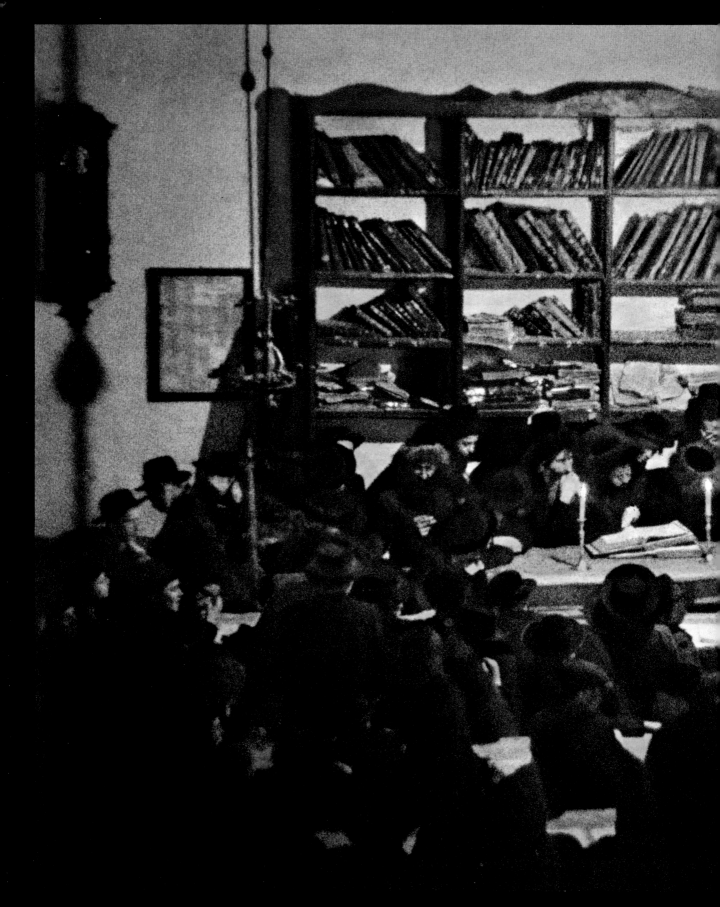

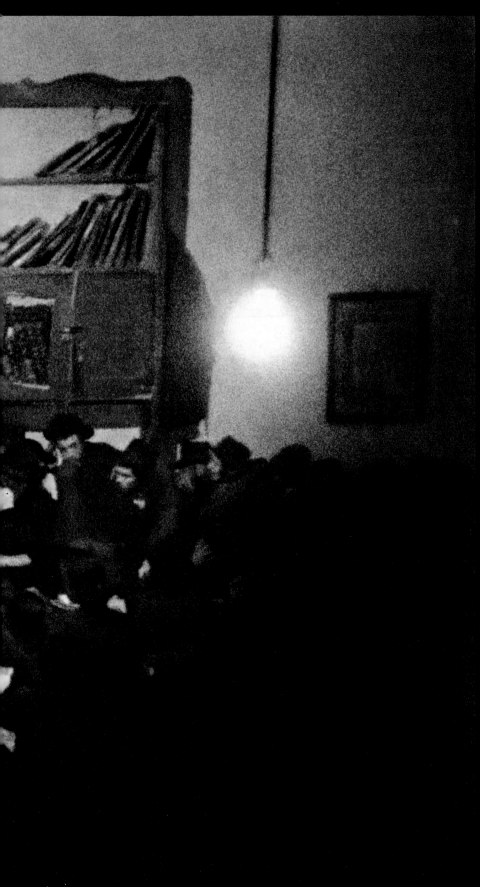

Munkacs, Hungary, 1938

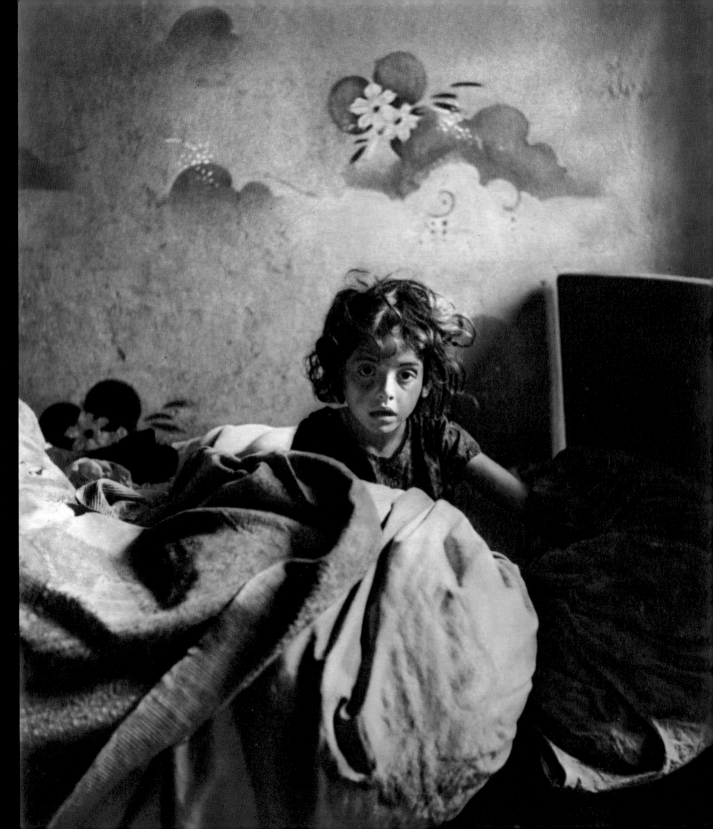

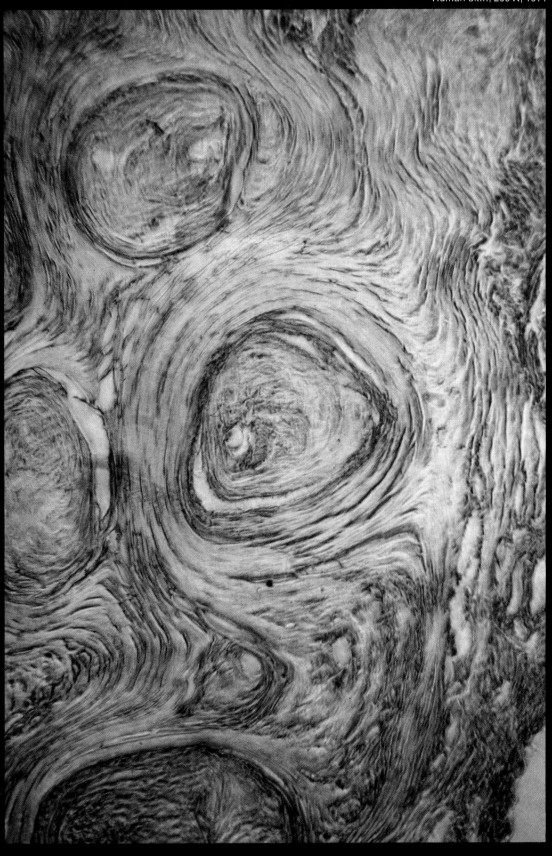

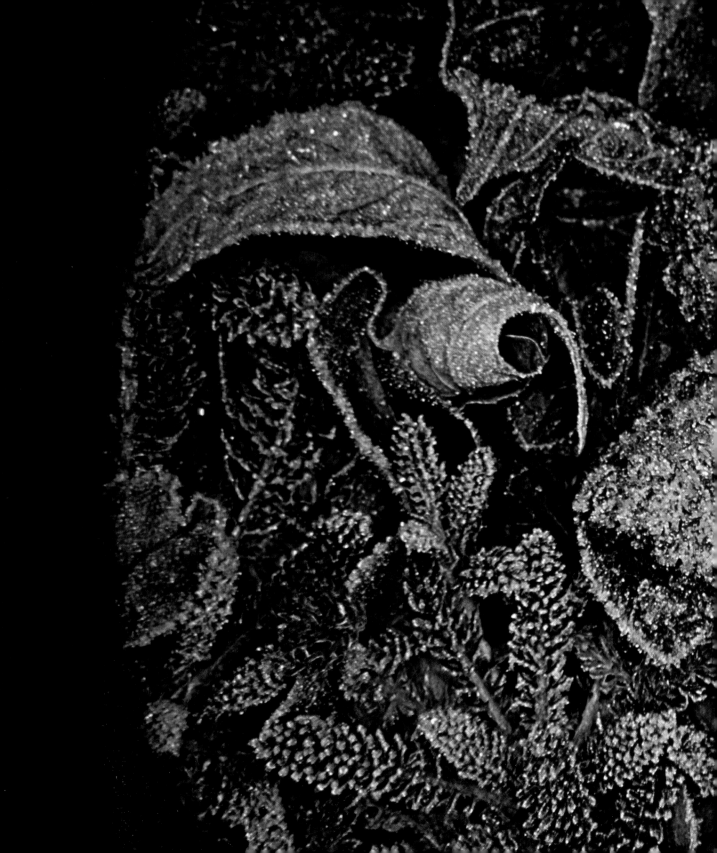

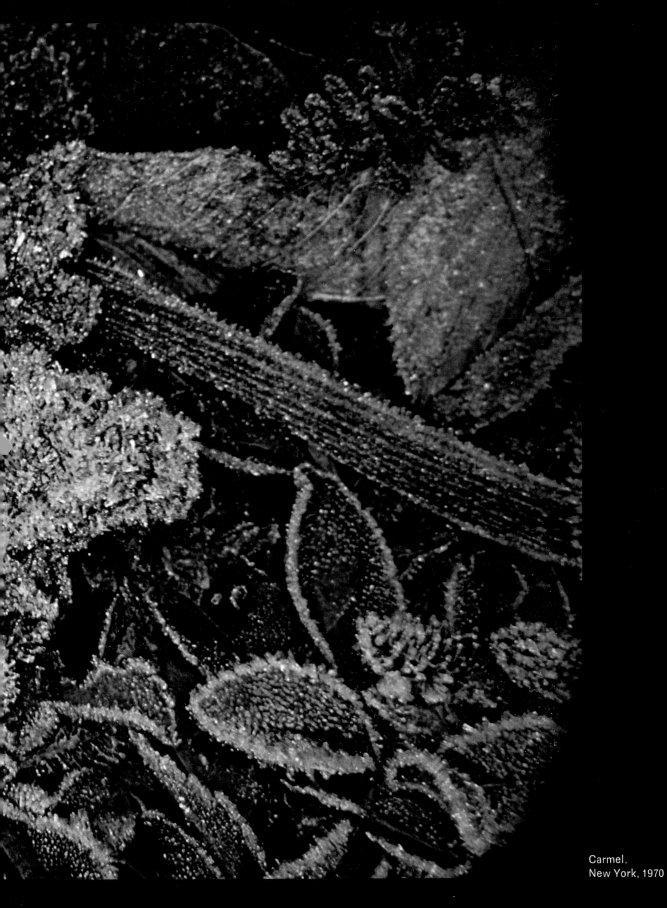

Carmel,
New York, 1970

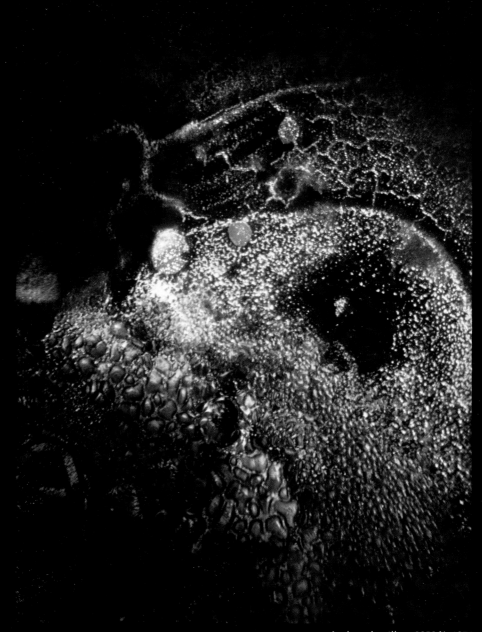

Anthrax bacillus, 2250 X, 1971

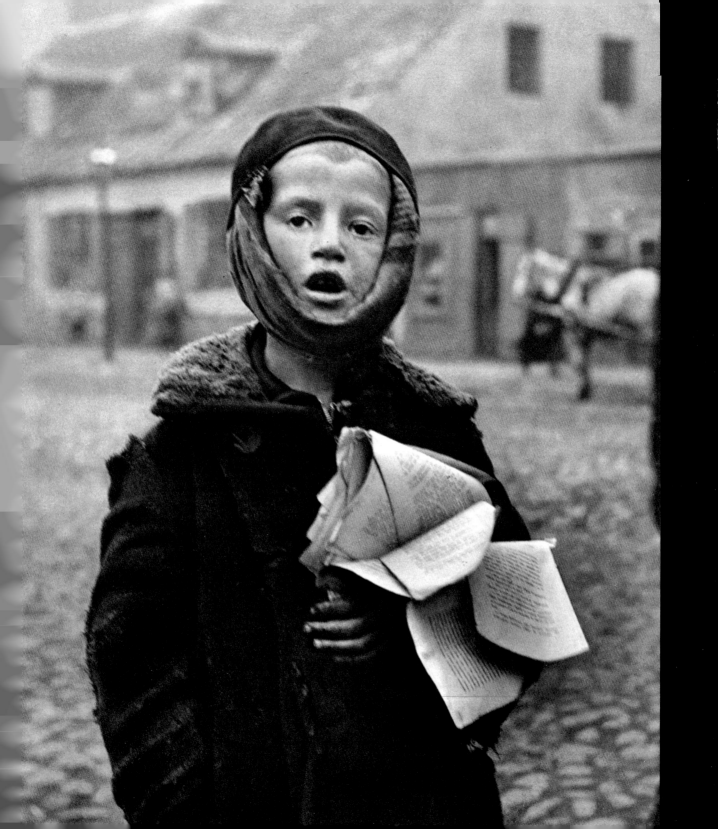

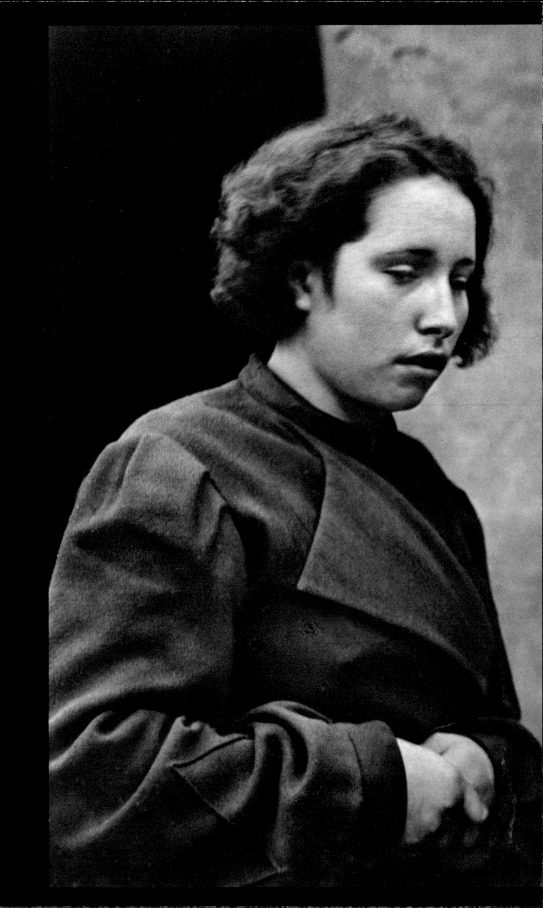

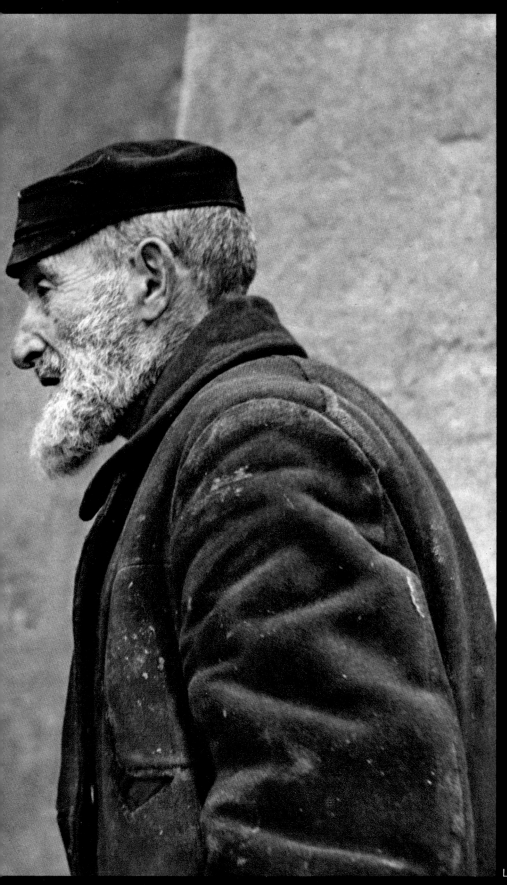

Lublin, Poland, 1937

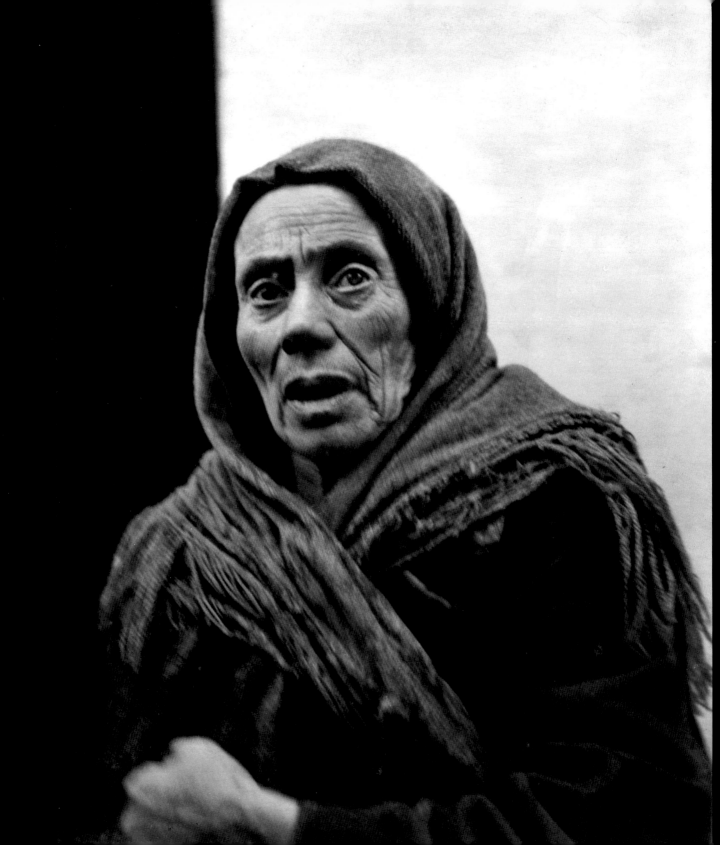

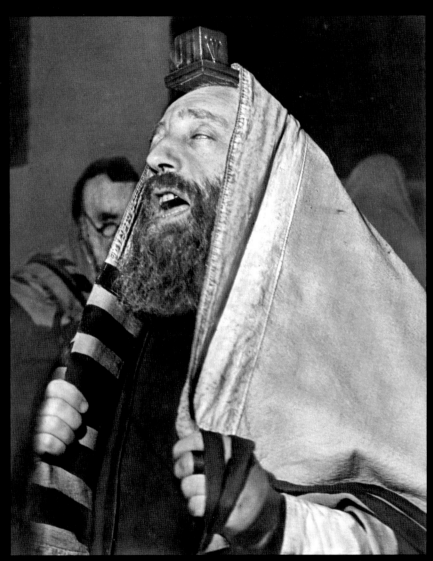

Germany, 1947

ublin, Poland, 1937

Bruce Davidson

"There is a feeling of necessity in his pictures. Bruce sees the wonder of contemporary life...he's in contact with the contemporary spirit." —Alexander Liberman

Bruce Davidson was born in a suburb of Chicago in 1933, but his life really began ten years later when he discovered the "magic" of photography. During those early years he set off to Chicago with his camera feeling "like Frank Buck, the explorer." The drive within him persisted and he acquired a degree in photography from the Rochester Institute of Technology; going further, he did postgraduate work in philosophy and art at Yale. During his army service, LIFE published *Tension in the Locker Room*, a photo essay he undertook while at Yale; the army immediately put him behind a camera. After his service, he freelanced in New York and Paris, becoming a member of Magnum Photos in 1959.

Throughout his career, Bruce Davidson has been involved with the lonely, the disenfranchised, the disinherited of this world...delving into the depths of their lives with his camera before him as a lantern for both himself and the viewer. His coverage of the Selma march and other civil rights activities in the sixties, Jimmy the Clown, the Welsh miners, the Brooklyn teen-age gang—all people who, in one way or another, are on the short end of the stick of life. At the onset of his career, his camera style was candid...the photographer as the unseen recorder. Gradually his style developed, eventually forsaking anonymity for known presence. His monumental work on East One Hundredth Street was, for example, done mostly with a 4x5 camera. His reasons: "A feeling, an impulse to work in a way I hadn't worked like really before." Searching in this manner, Davidson discovered that "when you are working with a view camera on a heavy tripod, the only thing connecting you [the photographer] and the instrument is your little finger on the cable release. You stand there looking, seeing the whole scene at once." For that was one of his greatest concerns—to see, to be seen, to be as one with his subjects. He sums up his experience with one word: "beautiful!"

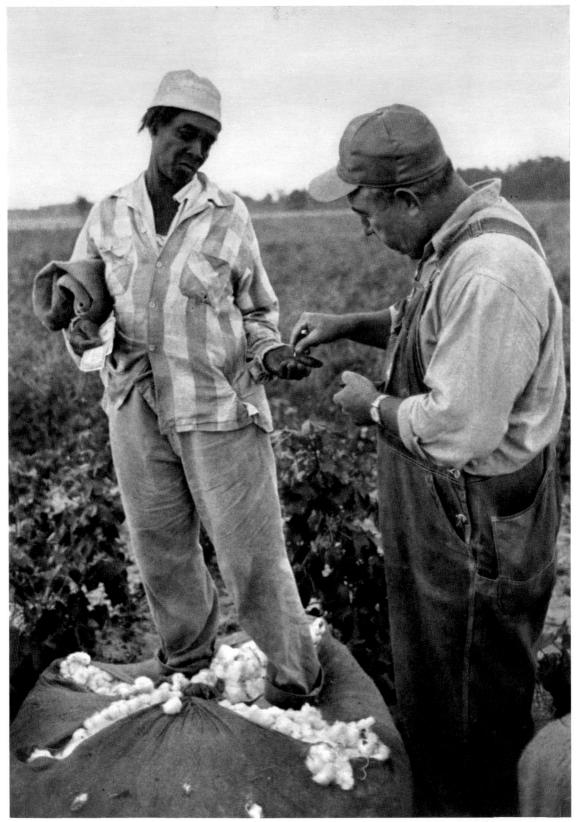

South Carolina, 1962

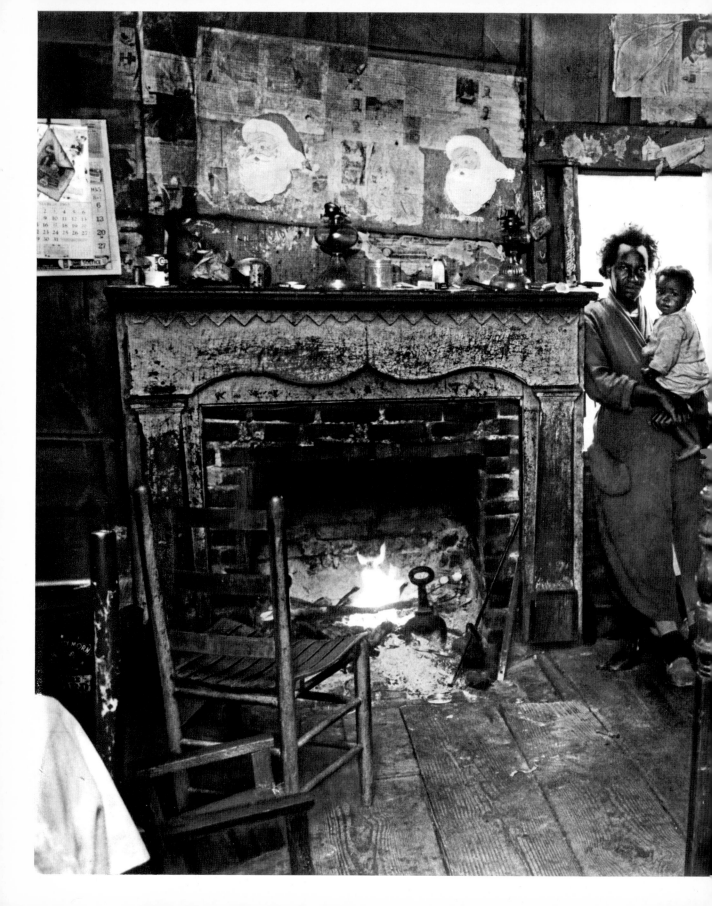

Alabama, 1962

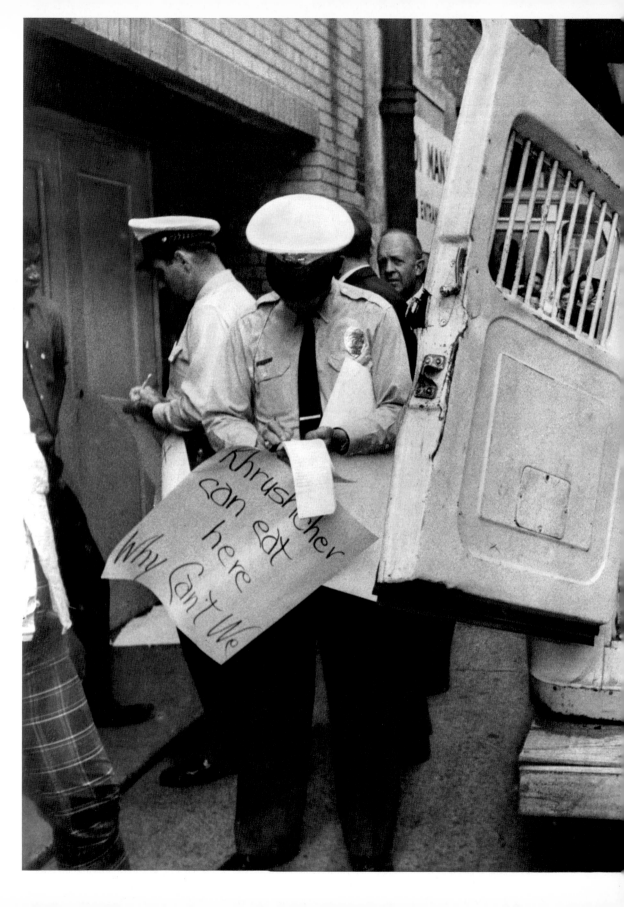

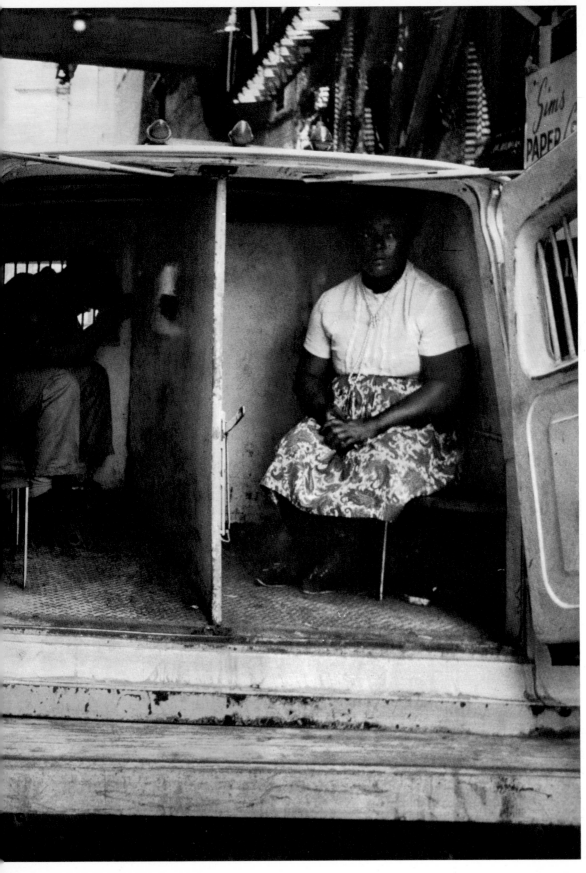

Birmingham,
Alabama, 1962

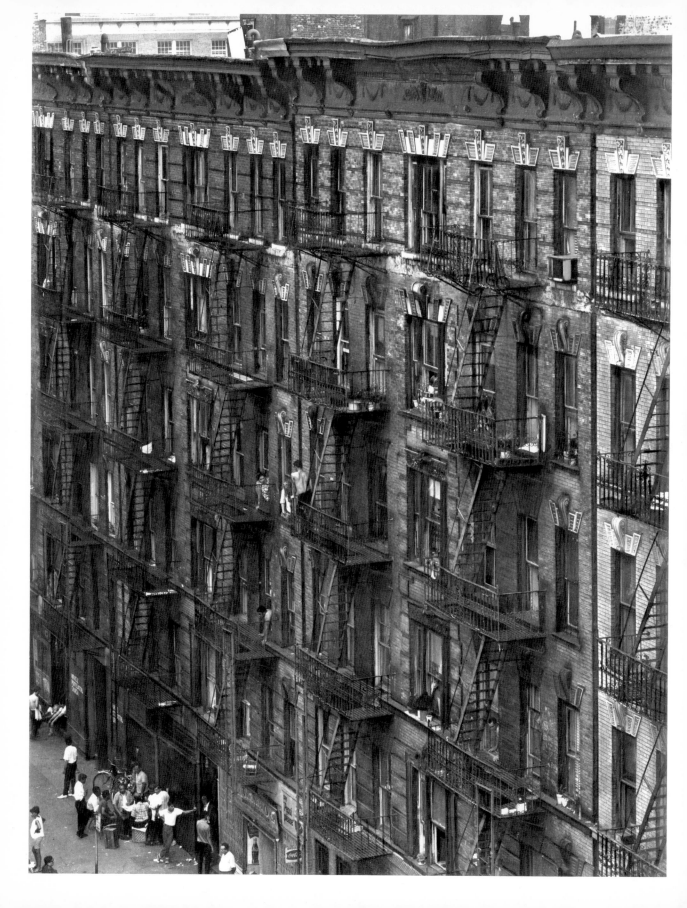

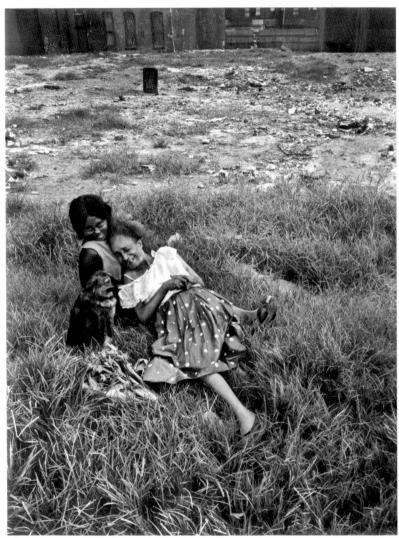

New York City, 1970

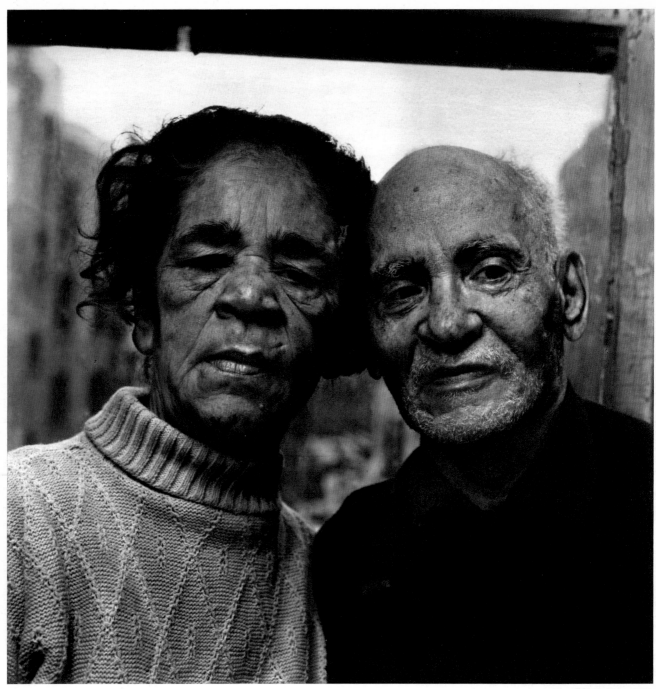

New York City, 1970

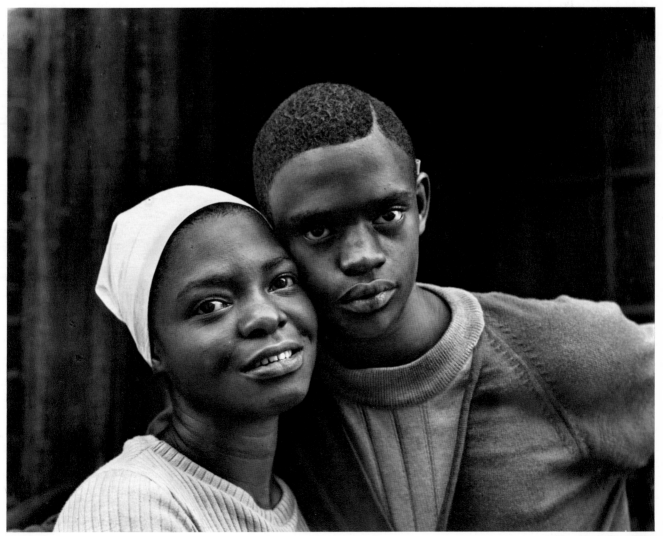

New York City, 1970

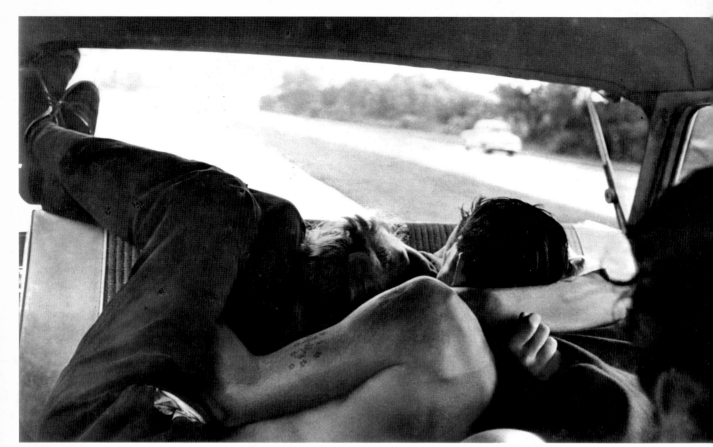

New York City, 195

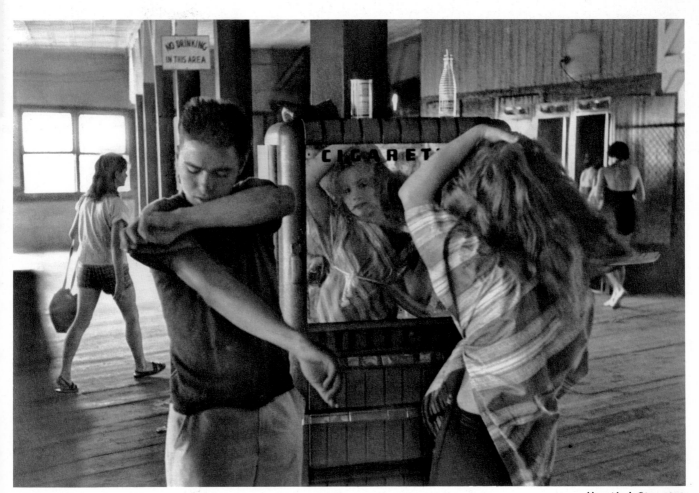

New York City, 1958

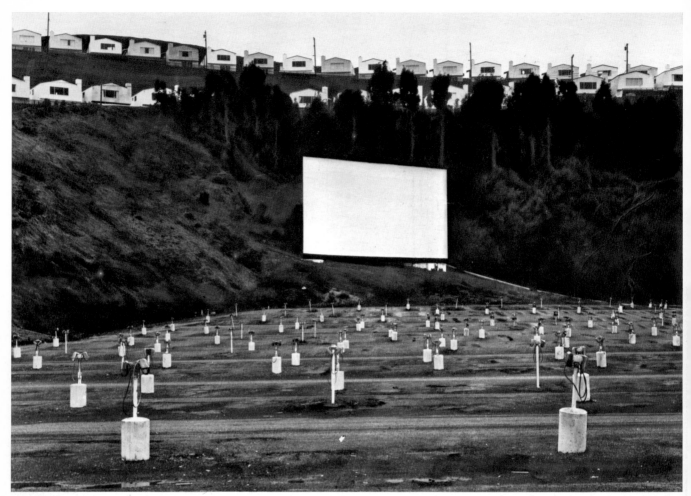

Los Angeles, 1964

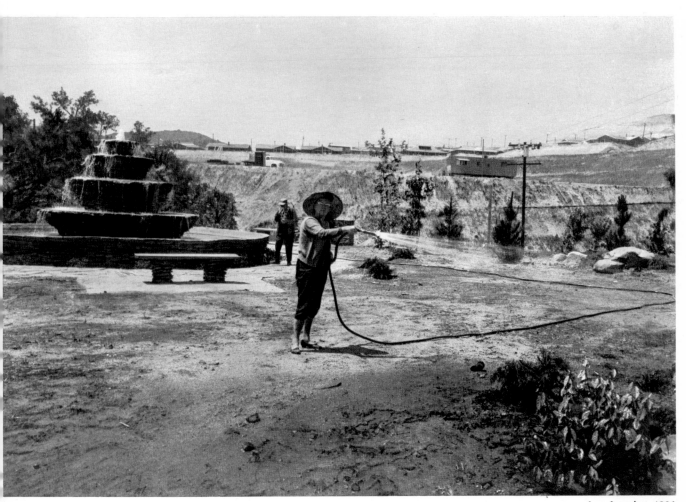

Los Angeles, 1964

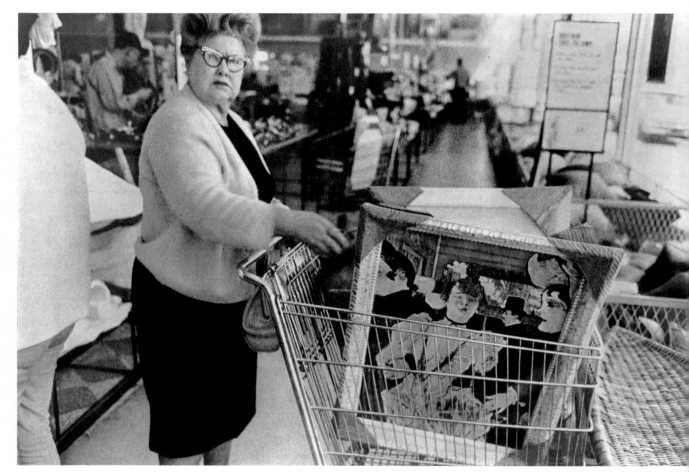

Los Angeles, 1964

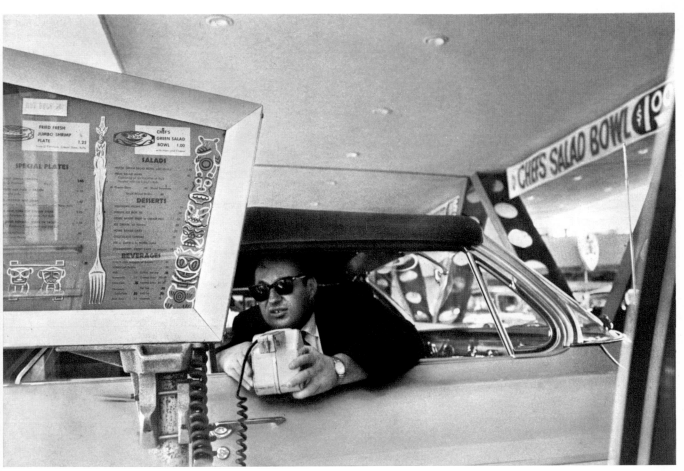

Los Angeles, 1964

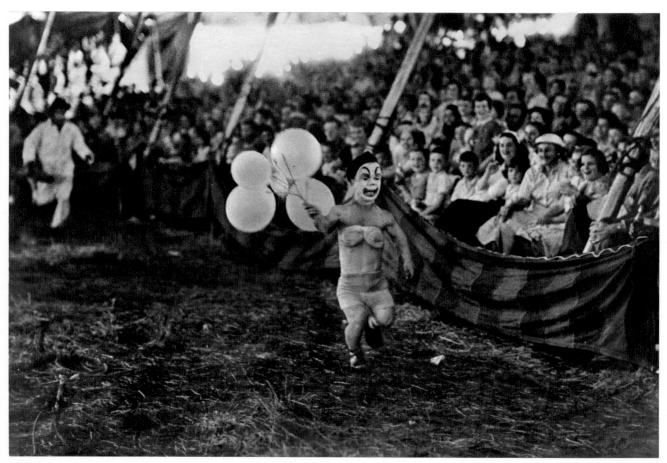

New Jersey, 1958

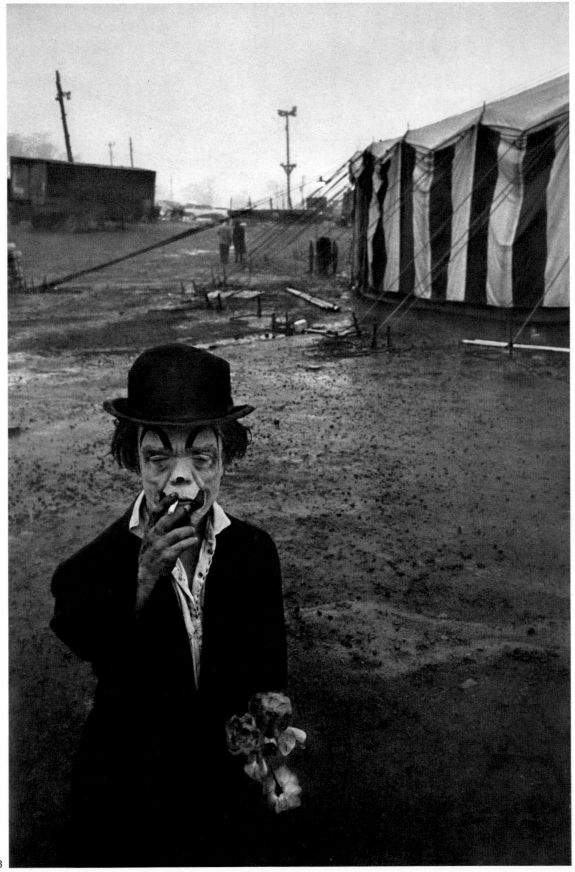

ew Jersey, 1958

Gordon Parks

"The funny and sad thing is that photography is an art, but these guys have such an inferiority complex about it that all they do is tag on gold-plate words where they aren't needed. If they'd only let it talk for itself."
—Gordon Parks

Many may wonder and ask, "What makes Gordon Parks run?" This man who never seems to stop photographing, directing films, writing prose, poetry and screen plays, and even music. What force propels him? Essentially, Parks is in the midst of constant search; always seeking out ways to communicate to others. Being black, and being both conscious and proud of that, he has sought to explain his role in life to himself and through himself to his fellowmen—be *they* black or white. Born in Fort Scott, Kansas, in 1912, his youth left a permanent mark on his thoughts. Parks may be invited to posh openings, lauded by the world's famous, and presented with honorary degrees, but, whatever, it appears that he returns to the seemingly inexhaustible well of his younger days for the watering of his ever-growing creativity. His first book and first feature film *The Learning Tree* were poetic replays of his youth. To his credit, he did not omit the savagery of those days, for they were equally formative. This desire to communicate was always in him, and then he found the tool. The turning point: he saw a newsreel that spoke to him. He felt he had something to say, too. Working as a train porter, he ran into Robert Capa one day, and he had the guts to show this photographic "god" his work. Capa offered encouragement and Parks, refueled, continued. He went on to join the Farm Security Administration in its last days. Afterward, Parks caught the attention of LIFE, and one year later, in 1949, was on staff. But he wasn't a specialist in black stories only; his wide interests made him expert in other coverage: his outstanding series on American composers (since he is one himself), his empathy for Flavio in the slums of Rio, even fashion. But it is his coverage of the Black Revolution of the sixties that marks Parks as a great communicator...his images made the misunderstandings, anger, frustrations, and violence of that period comprehensible to those who otherwise would have remained ignorantly resentful. While no man is an island, certainly, also, neither is any race...white or black. Parks helps bridge that gap.

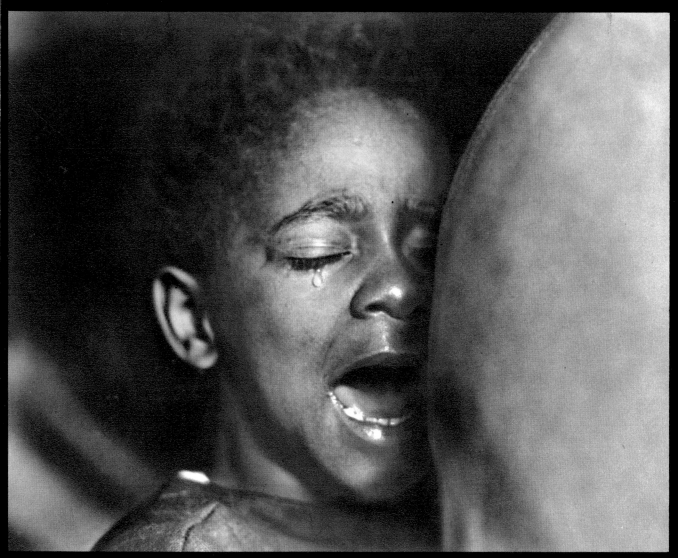

New York City, 1968

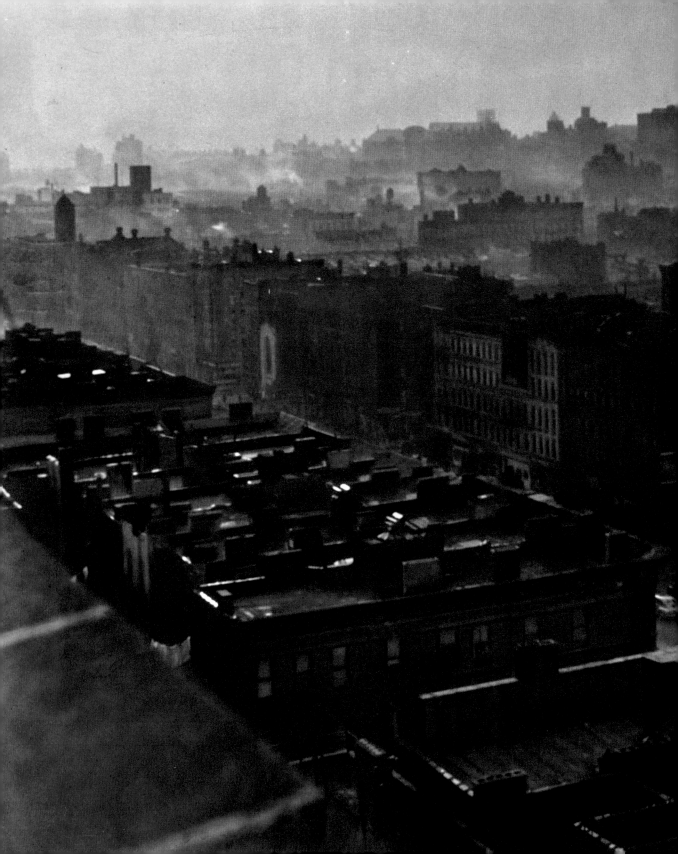

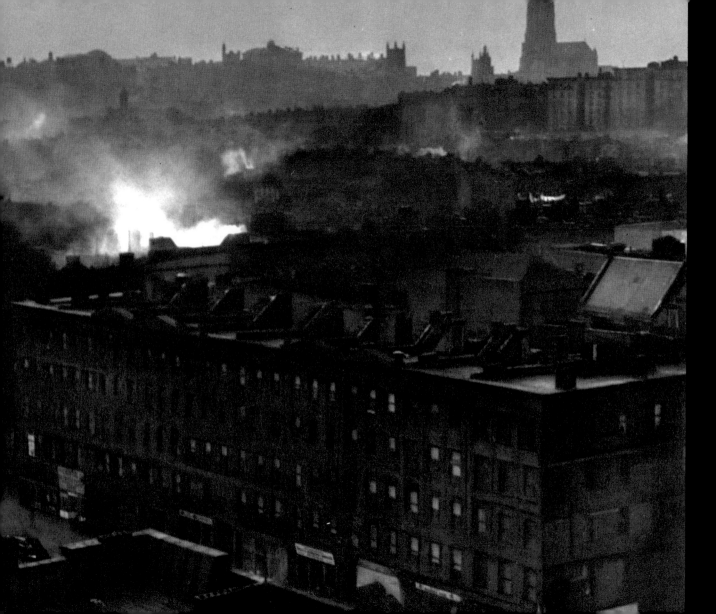

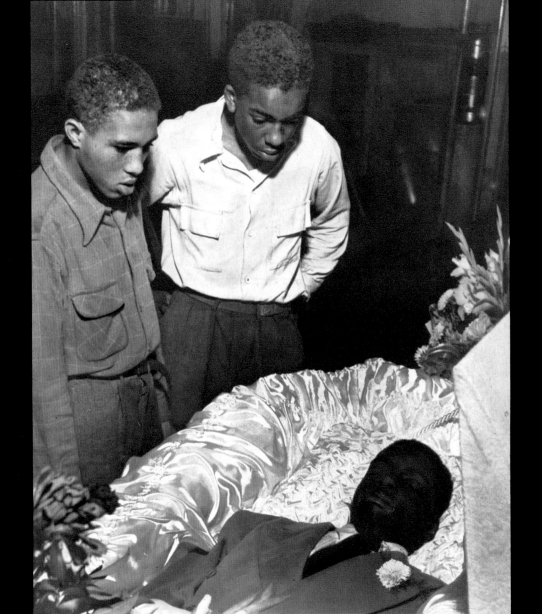

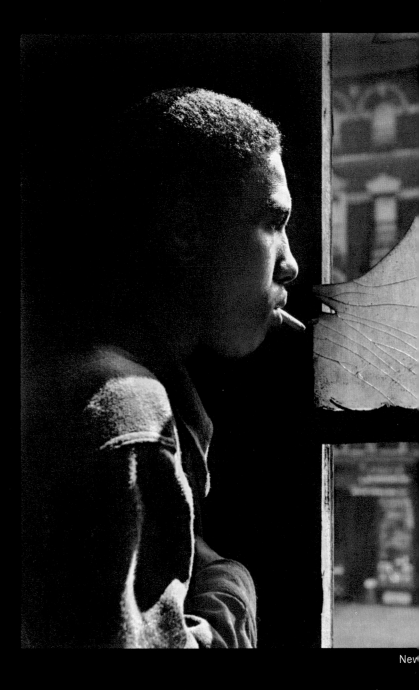

New

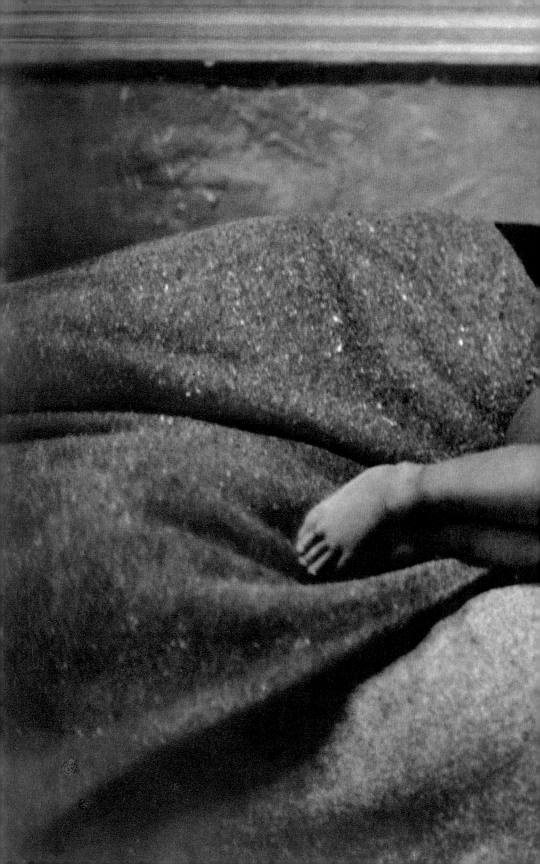

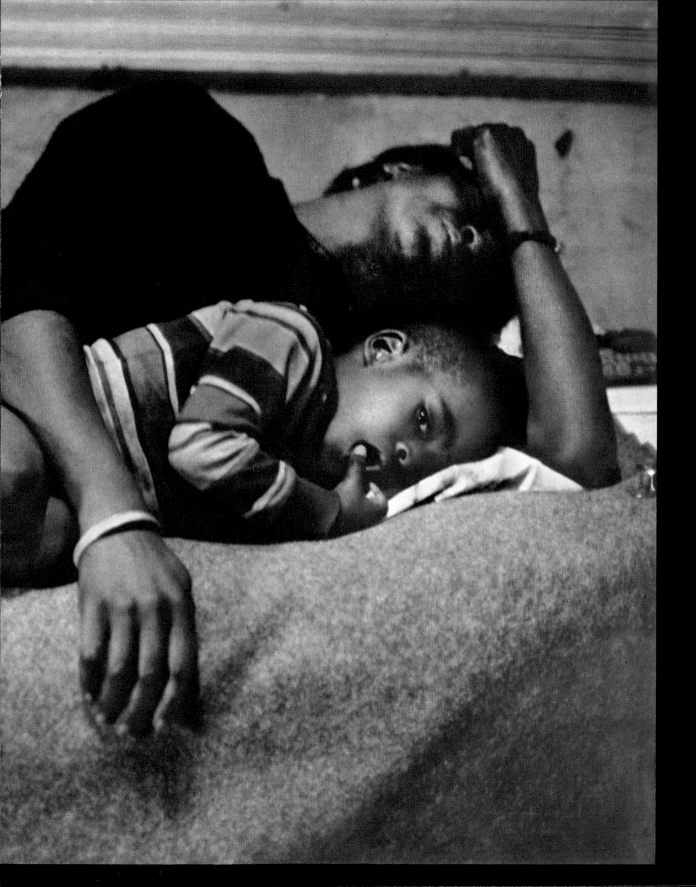

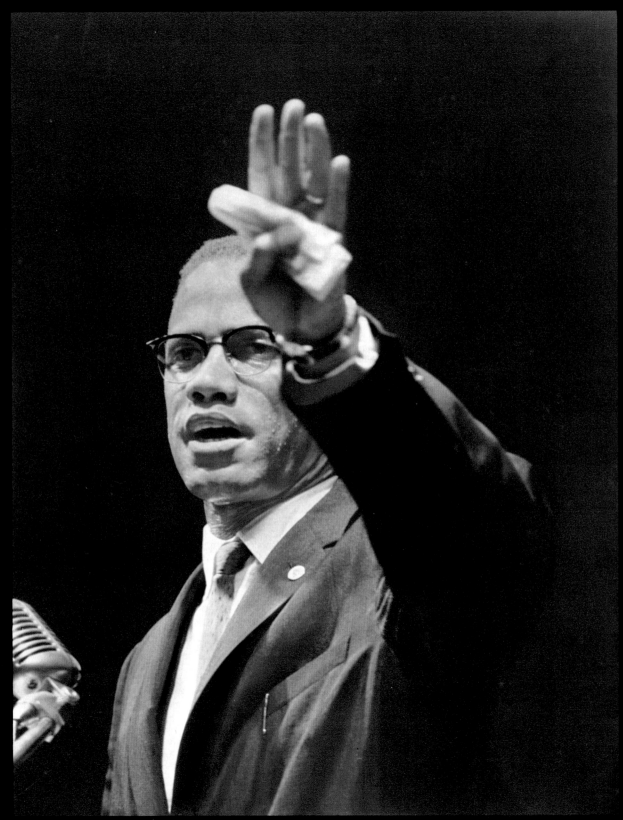

Malcolm X, 1960

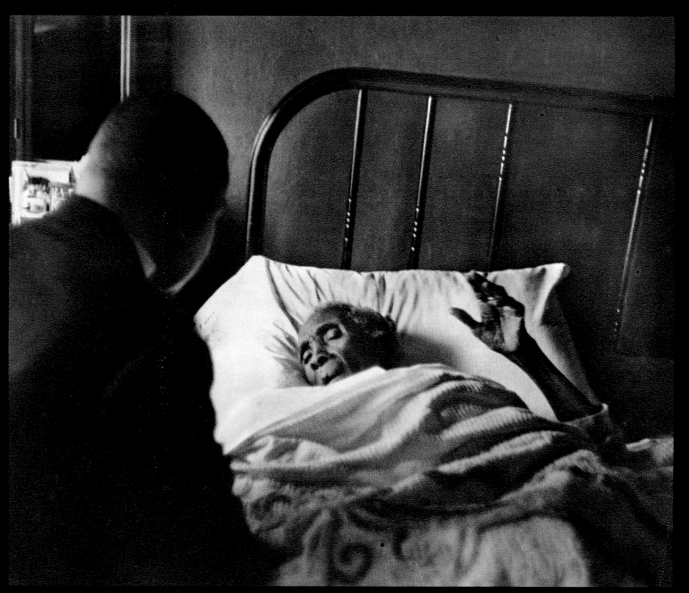

Chicago, 1950

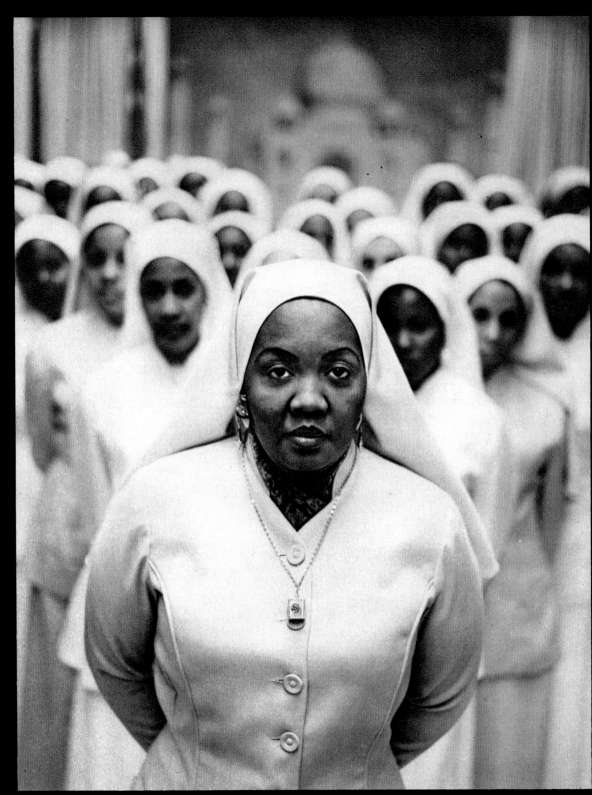

Chicago, 1960

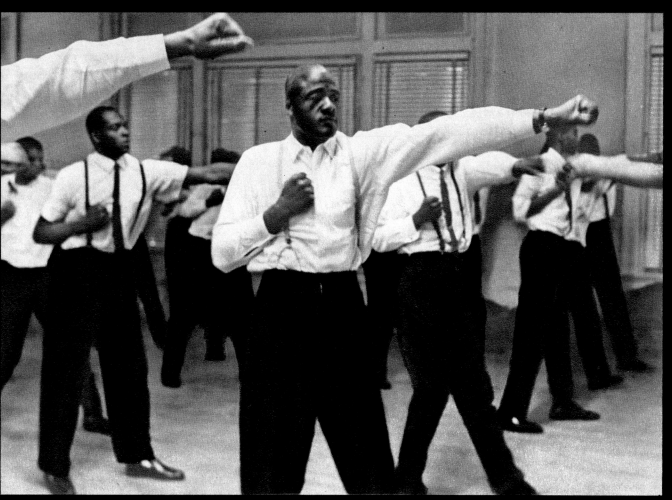

Chicago, 1960

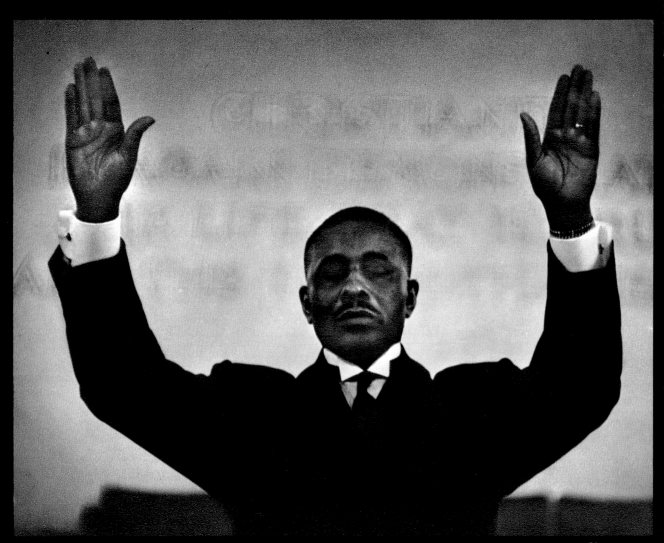

Chicago, 1950

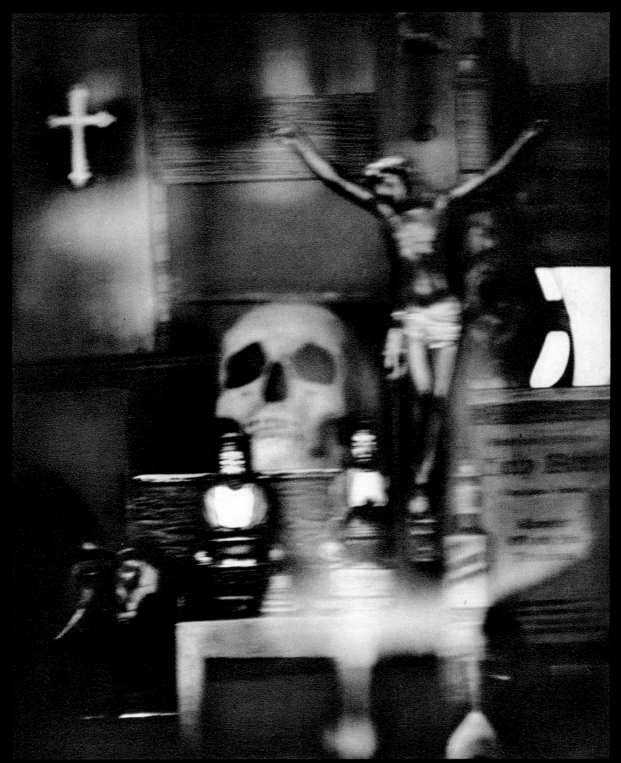

New York City, 1950

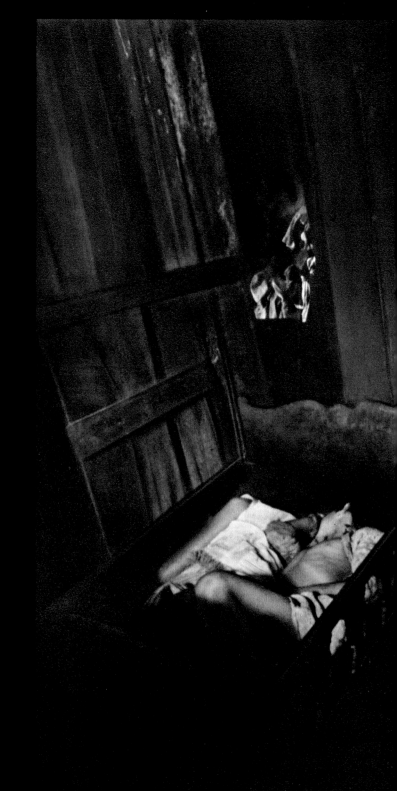

Rio de Janeiro, 1961

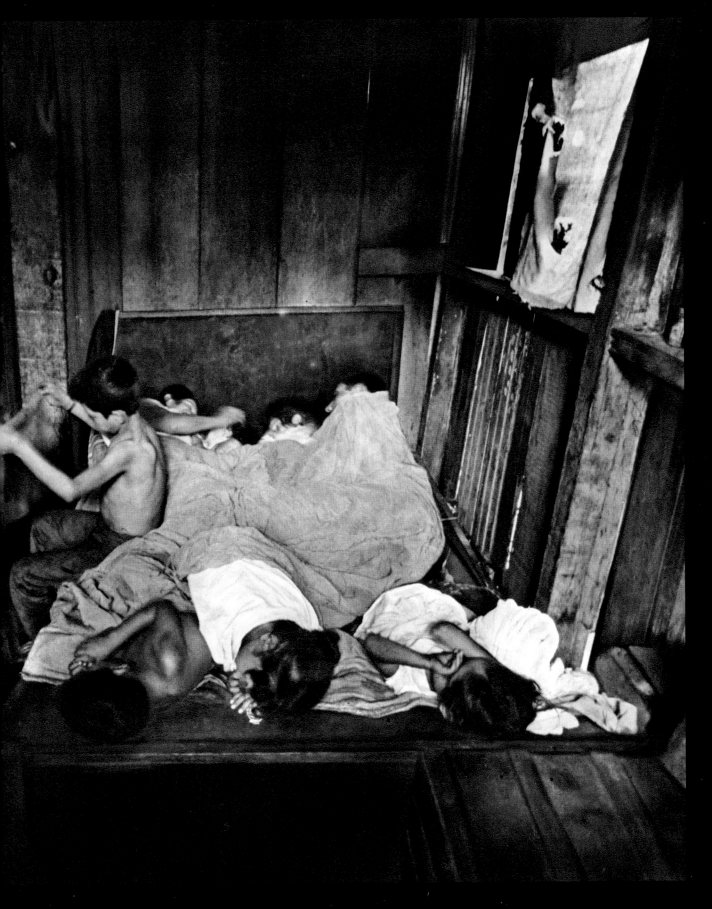

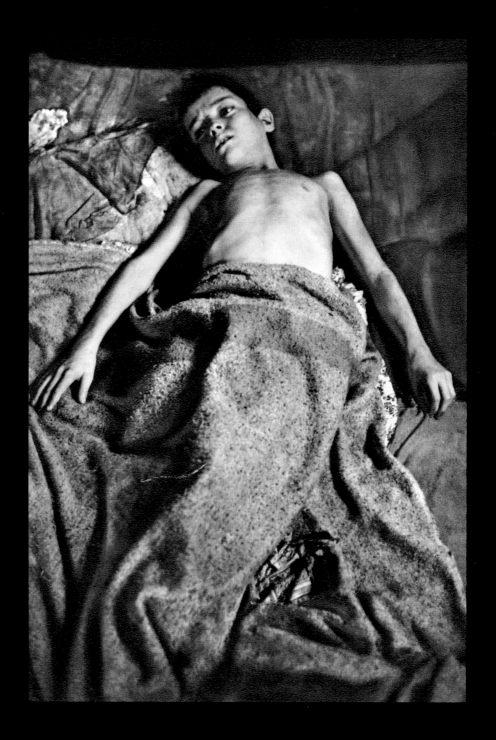

Rio de Janeiro, 1961

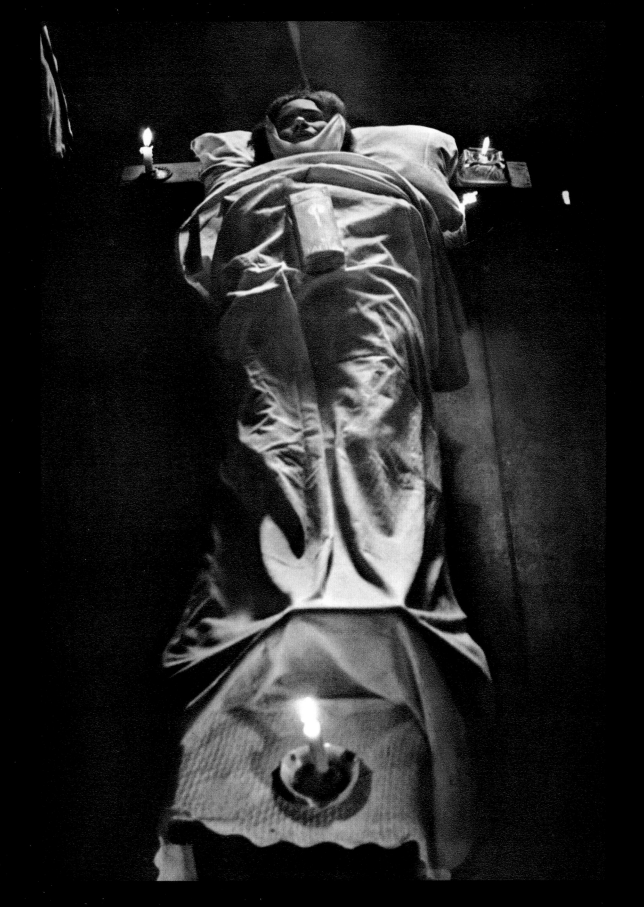

Ernst Haas

"He is a free spirit, untrammeled by tradition and theory, who has gone out and found beauty unparalleled in photography."
—Edward Steichen

Were it not for World War II, it's quite likely that somewhere on a charming street with a musical name in Vienna there would be a brass plaque next to a rococo door reading "Ernst Haas, M.D." Luckily there isn't. Born in 1921, Haas attended medical school, but the war and his own artistic nature were too overpowering. The war also provided Haas with his photographic break—the essay on the returning Austrian POWs. *Homecoming* was published in HEUTE, then throughout the world through Magnum. Later, Robert Capa asked him to join the newly formed cooperative picture agency. For many years Haas worked in a straight reportage style while covering the globe, even including the demise of the French empire in Indochina during 1954. But gradually Haas became drawn to the possibilities with color. In a way, he came closer to reality through the seemingly unrealistic effects of blur and other techniques. This approach provides him with a means to drive nearer to the core of experience—the true reality, for that is what we feel and remember, not simply sight alone. Van Gogh, in describing one of his paintings, wrote, "I have tried to express the terrible passions of humanity by red and green. The room is blood-red and dark yellow. The color is not true from the realistic point of view; it is a color suggesting some emotions of an ardent temperament." Here, Van Gogh's description of *Night Café* fits a goodly portion of Haas's extraordinary photographic book THE CREATION. Haas has perfected his vision so well that he is even capable of achieving similar aesthetic marvels in black-and-white, as shown by the last two pages of this section. A polluted river looks like the cosmos in flux! Nature, the forces that drive, these have been the prime interests of Haas—be they manifest in man, animal, or spirit. His empathy with the mustangs of the film *The Misfits;* the Indians he has been photographing and communicating with for over fifteen years; the snow nude of Aspen—all of these subjects involve Haas not simply as a man capturing images, but a man seeking to delineate spirit.

Arthur Tcholakian

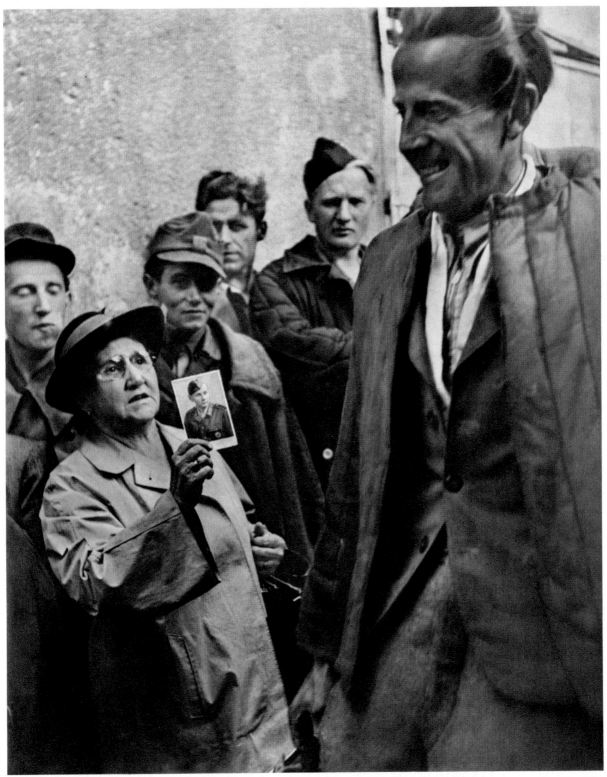

Vienna, 1947

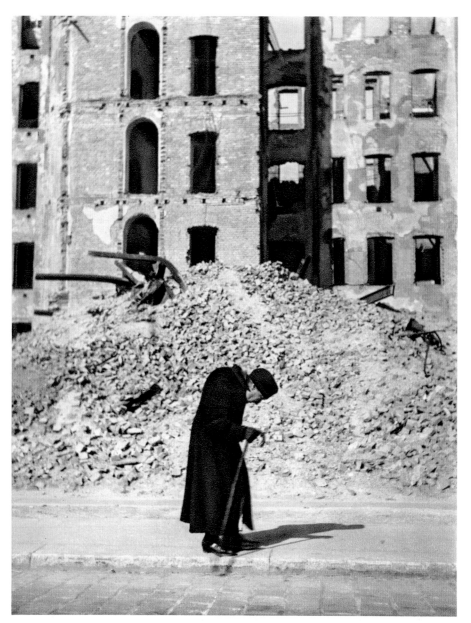

Vienna, 1947

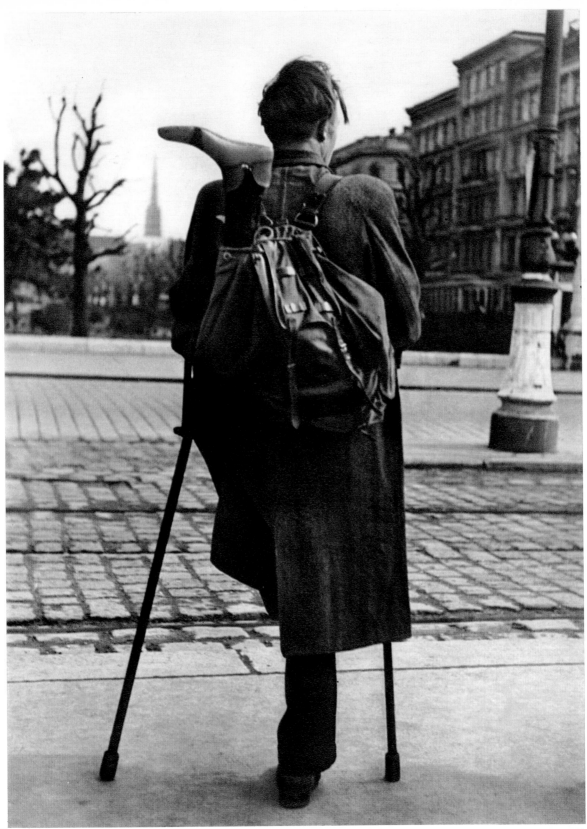

Vienna, 1948

U.S.A., 1960

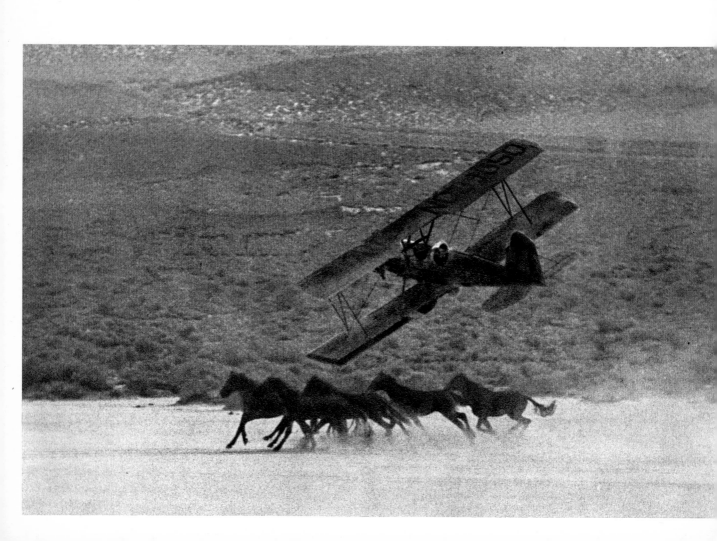

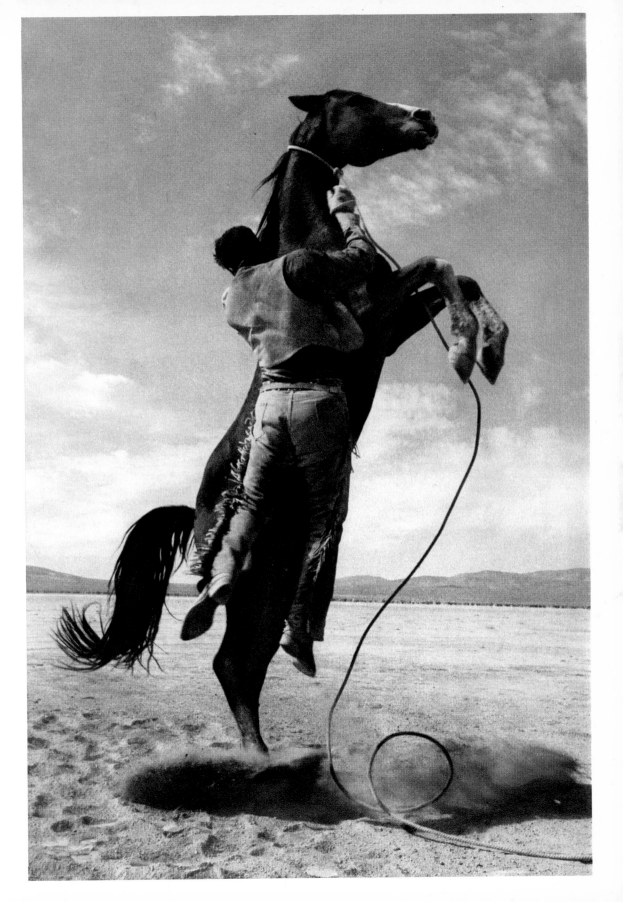

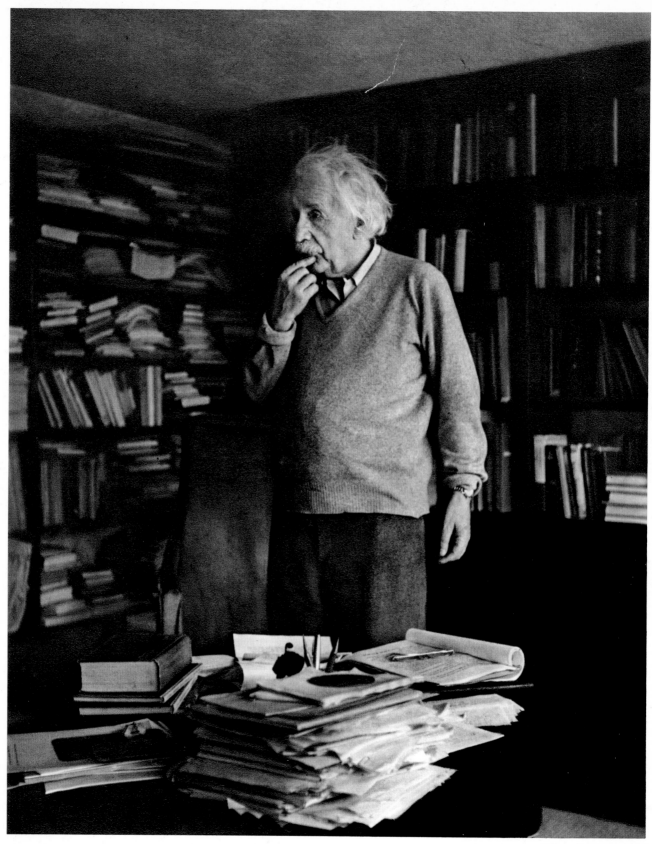

Albert Einstein, 1952

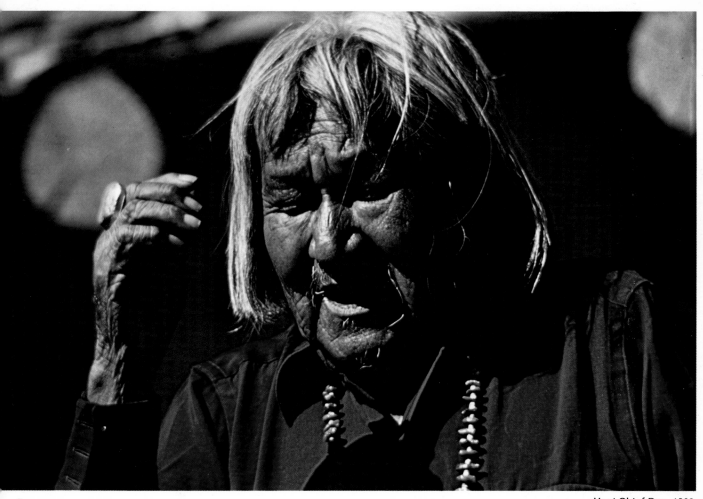

Hopi Chief Dan, 1960

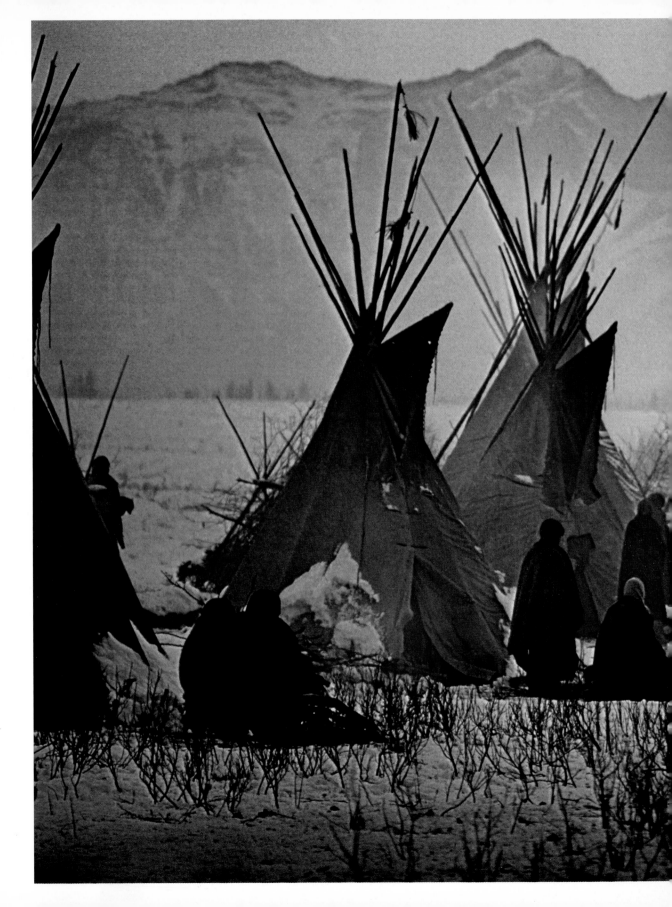

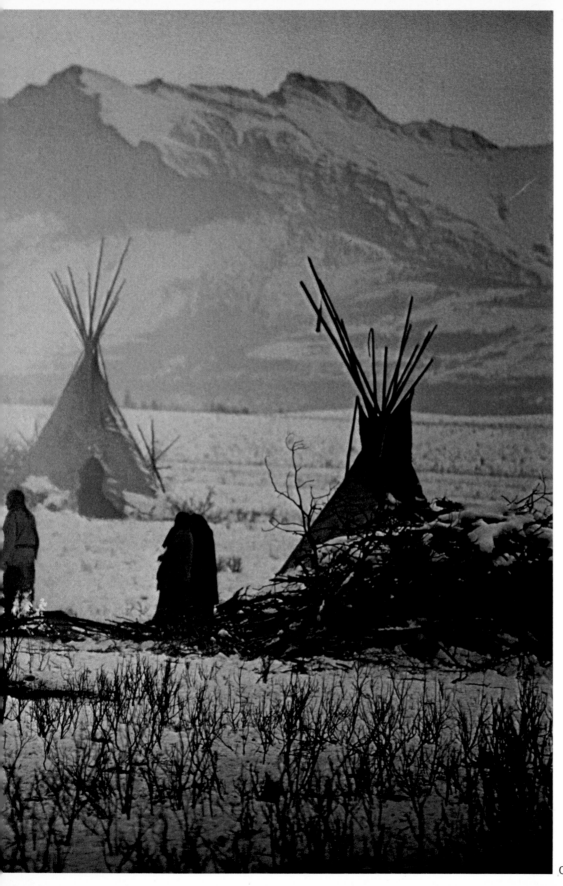

Canada, 1970

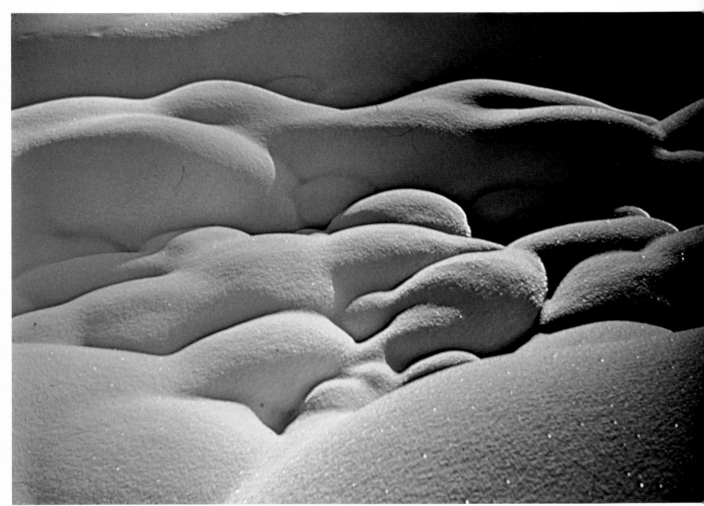

Aspen, Colorado, 197

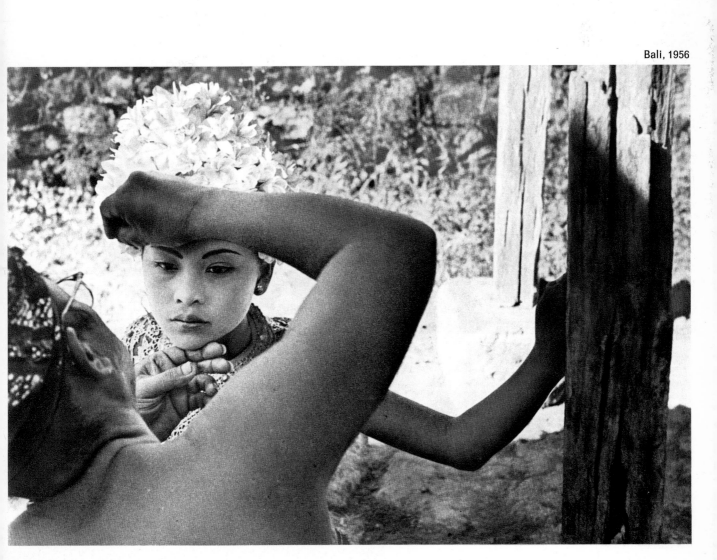

Bali, 1956

Bali, 1956

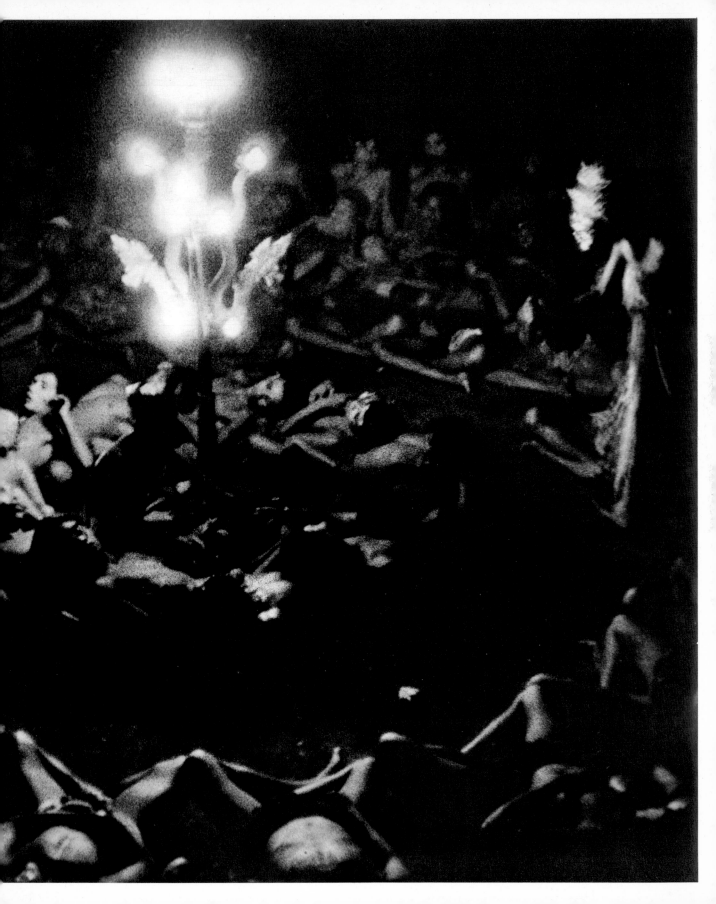

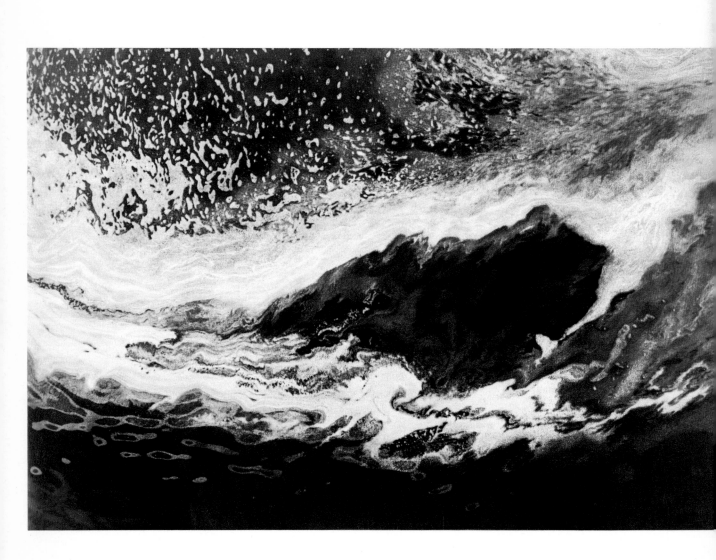

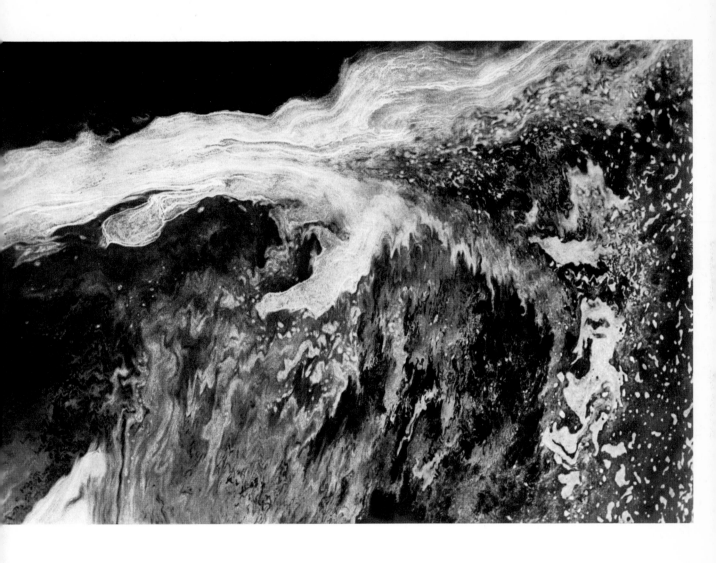

os Angeles, 1971

Hiroshi Hamaya

"This may be only my way of feeling, but in each of these pictures I sense and feel man. Thus, I have gained some new insights into man through having looked deeply at nature."
—Hiroshi Hamaya

In the preface to his monumental work, LANDSCAPES OF JAPAN, Hiroshi Hamaya explains, "It has been thirty-three years since I began in photography; thirty-one years since the moment I decided to take up photography as my life's work. During all this period, what captured and held my interest was people and their problems. My work," Hamaya points out, "began with the main object, man. I, who was born in downtown Tokyo, first began taking pictures of the downtown people. My thoughts at that time on photography were, of course, shallow, and since I was young, my interest was limited to the manners and customs of the people—but anyway, my work began with pictures of human beings." Hamaya in his life-long search for the essence of man has discovered the enormous role played upon us by our environment. It is one thing to state that we do not live in a vacuum, but it is another to discover and ultimately prove this through photography and photographic experiences engendered within the viewer. To better understand his subjects, Hamaya has delved deeply into Japanese folklore, a rich vein for any man to mine. His thoughts about his photography dealing with the "Snow Country" explain his relationship to his subject and the subject's relationship to the world in which he lives. "The harvesting of rice is not simply an exchange of energy through physical labor. For the peasants who made this narrow and lean Japanese archipelago into a land of gold, a deep and intimate communion with some deity was a necessity. The fact of the festive rites of Japanese farm people occurring a number of times a year speaks of the great hardships these people had endured." From Hamaya's statements it becomes clear that his landscapes are really "manscapes" because his images constantly underline the insoluble union to which we are forever bound.

Hiroo Tsuzuki

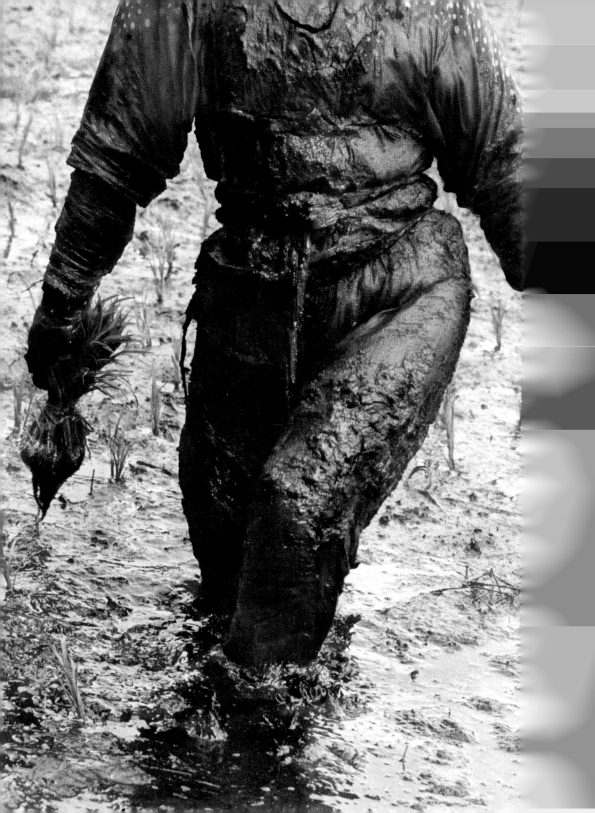

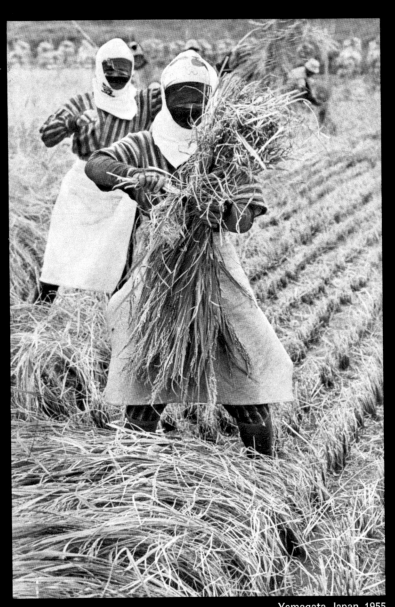

Yamagata, Japan, 1955

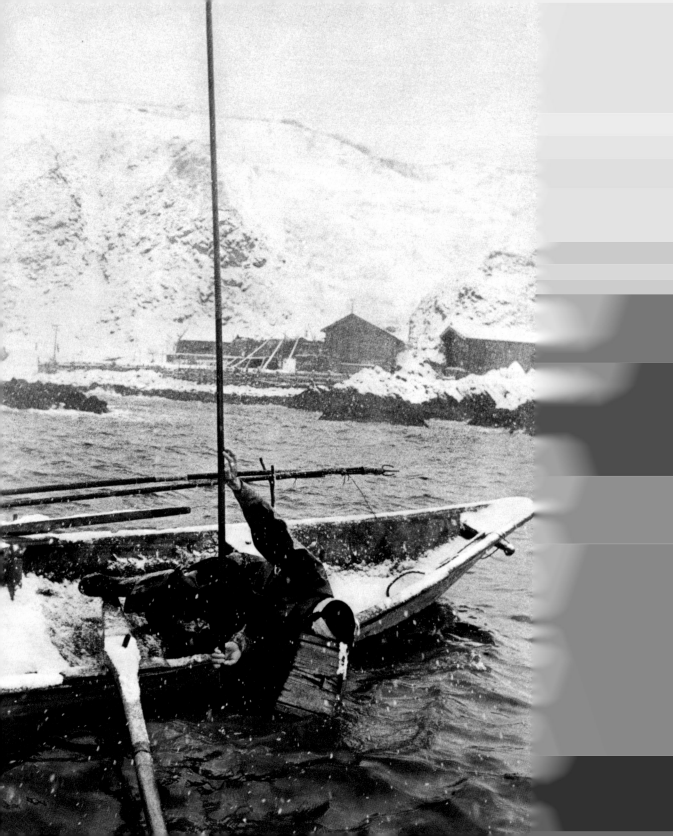

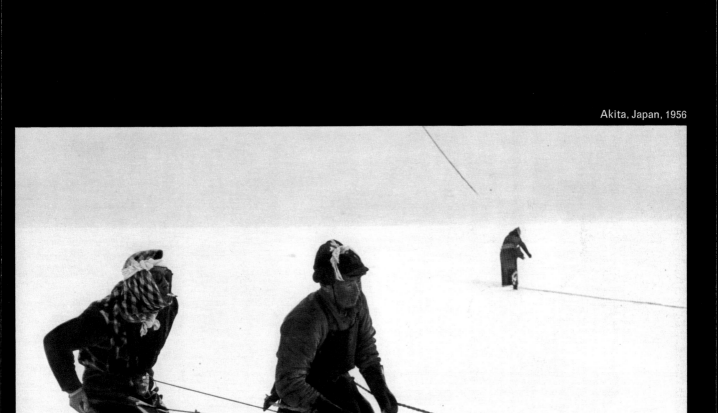

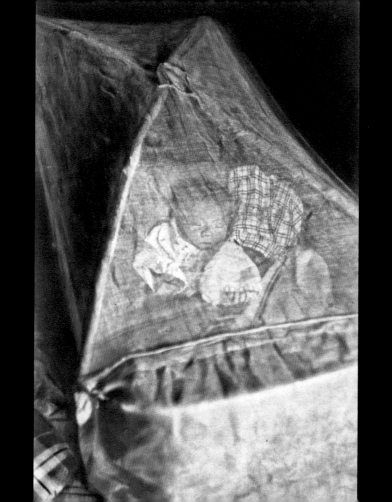

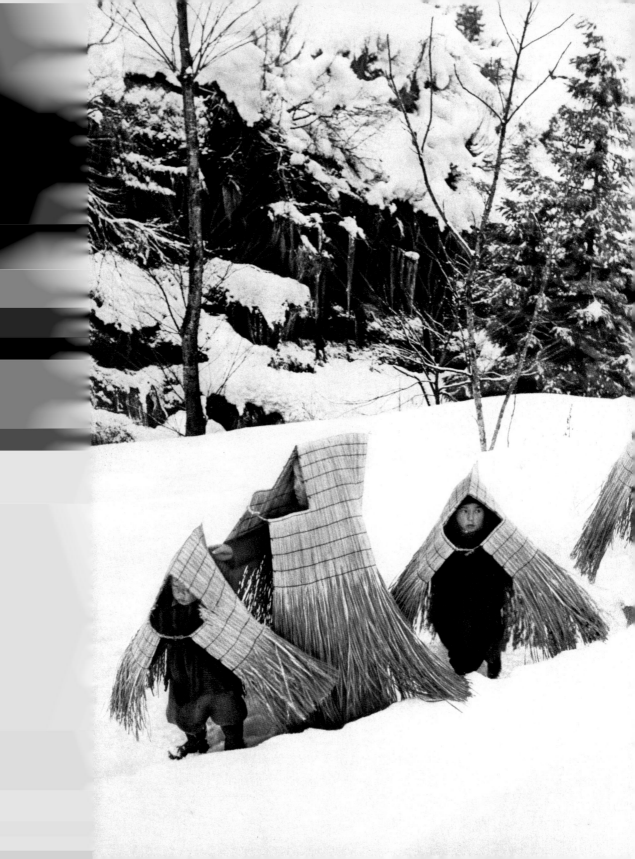

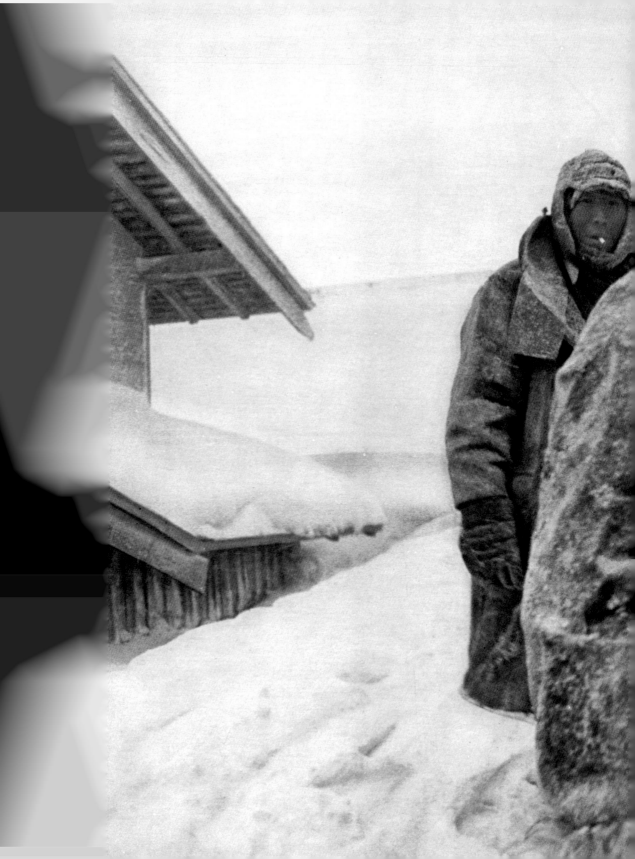

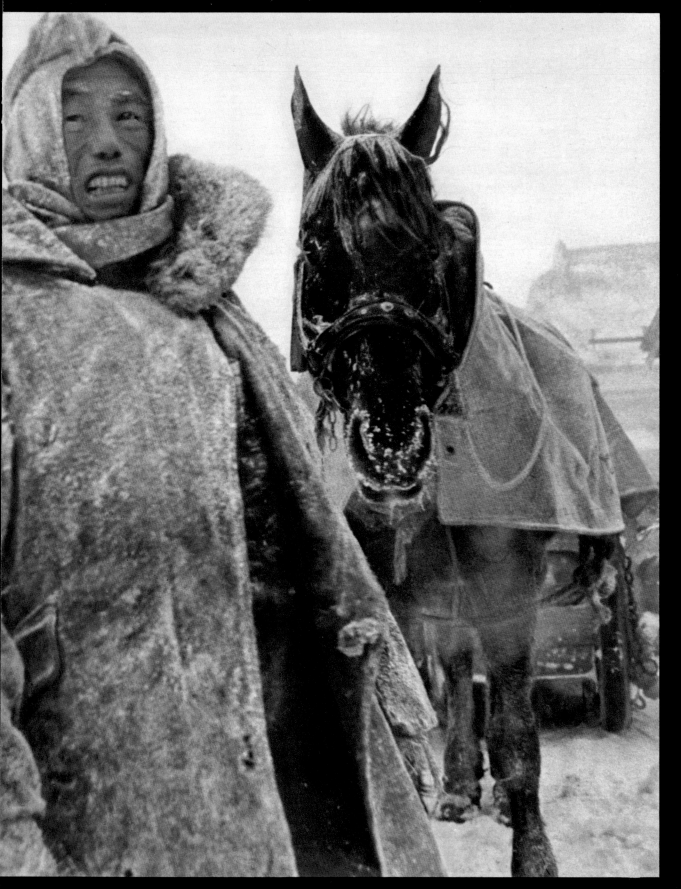

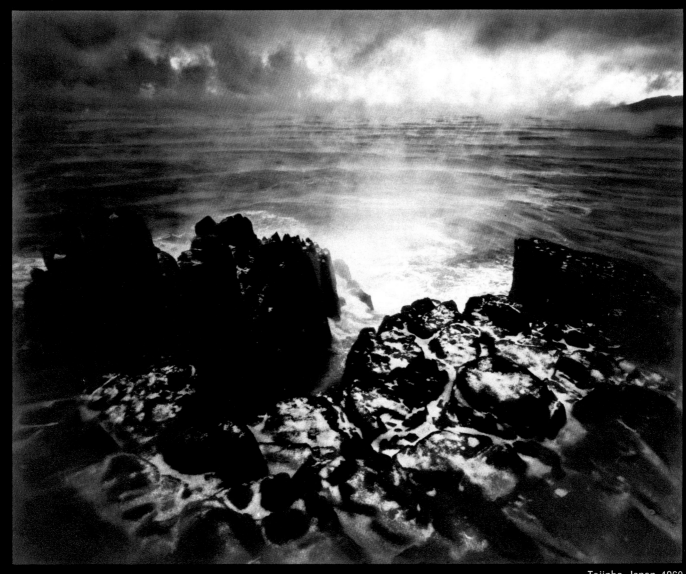

Tojinbo, Japan, 1960

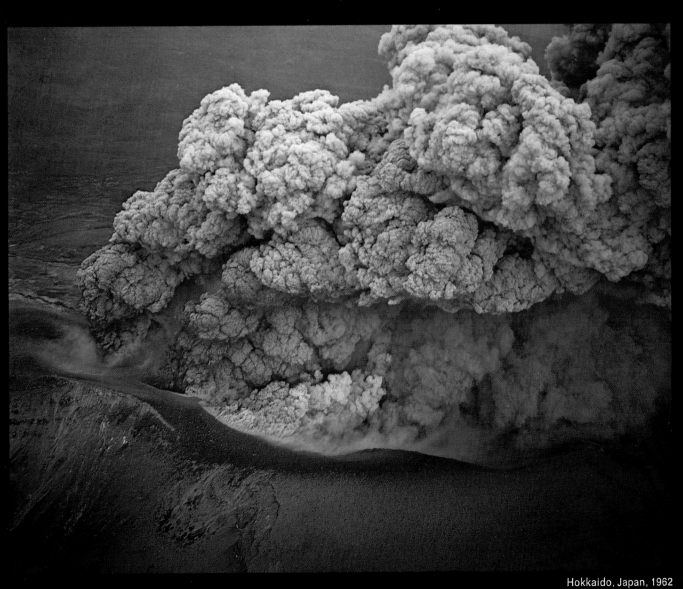

Hokkaido, Japan, 1962

Toyama, Japan, 1964

Hokkaido, 1965

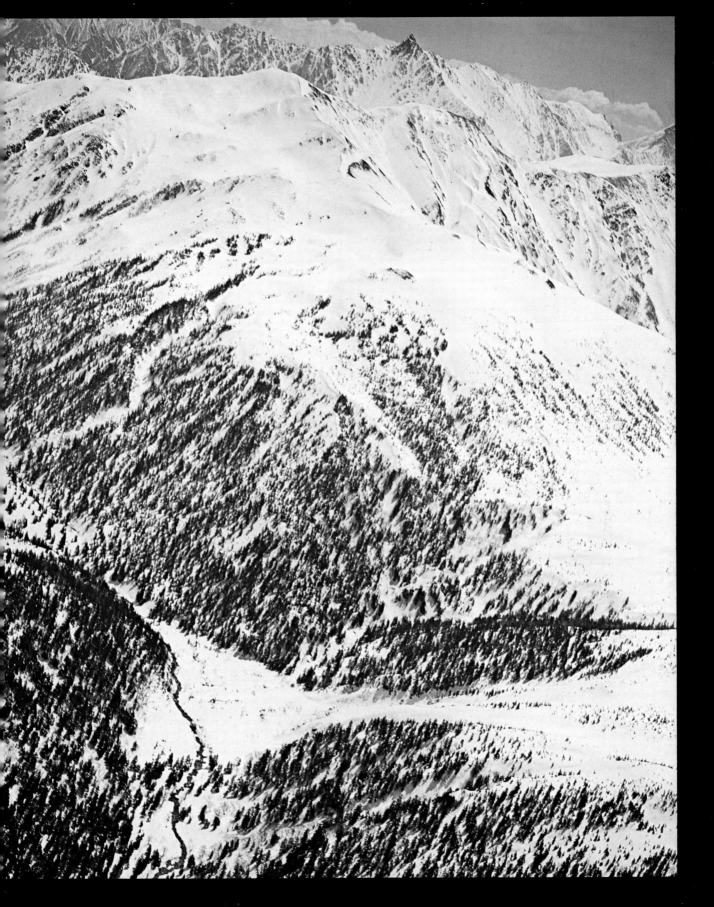

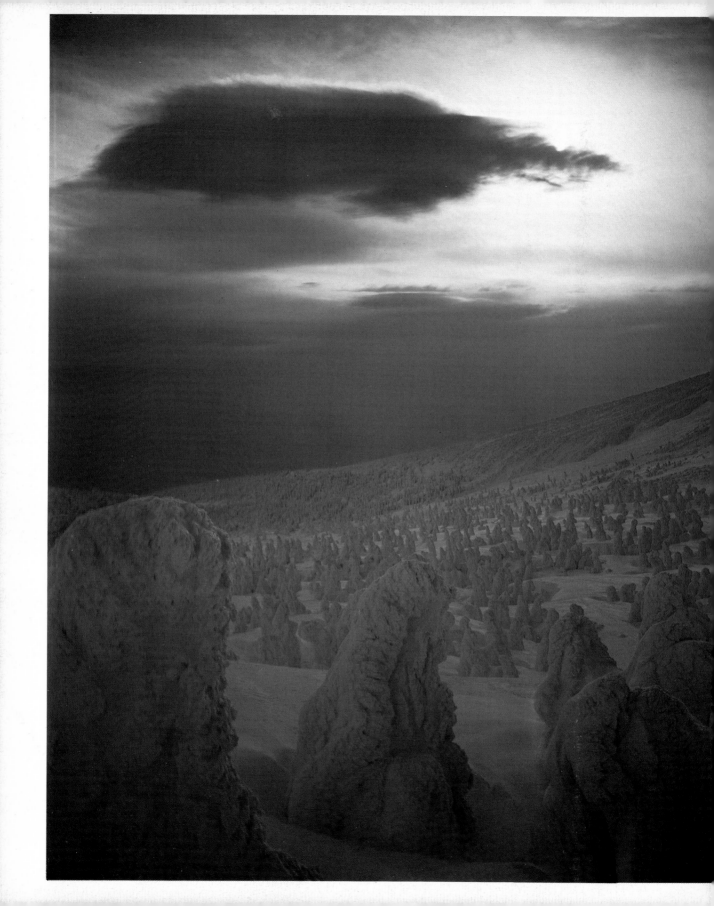

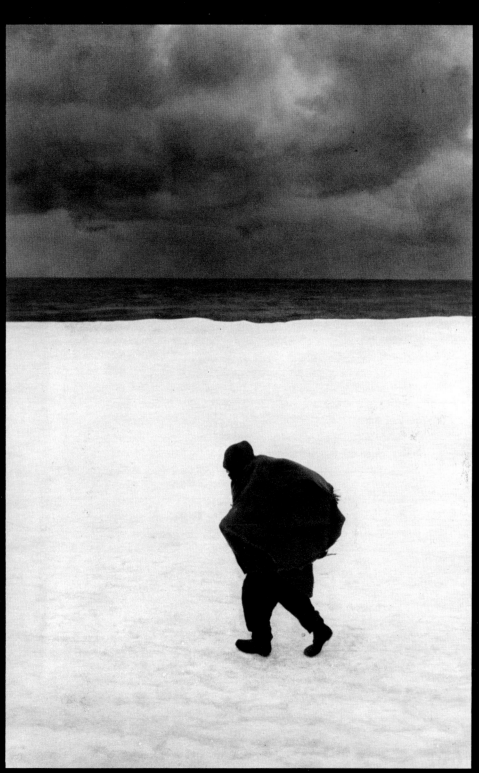

Tsugaru, Japan, 1956

Donald McCullin

"I only use the camera like I use a toothbrush. It does the job."
 —Donald McCullin

Only five years after he was born in a poor section of London, Don McCullin had his first encounter with war—he was evacuated to the safety of the countryside from the blitz that Hitler had ordered to rain down upon London in 1940. Seemingly, the hardships and poverty of his early life prepared him best for the unimaginable horrors he was to photograph when he was to become a successful war photographer. Even though he had a scholarship at thirteen to the Hammersmith School of Arts and Crafts, the death of his father made it necessary for him to relinquish it and to work at odd jobs. It was the Royal Air Force that first gave McCullin a camera, but it wasn't until later on that he discovered what he could do with it and what it could do for him. McCullin represents the Robert Capa tradition; not just being in the middle of the action and *close* to it, but the drive that puts him there in the first place. Not unlike Capa's gaining fame by his coverage of the Spanish Civil War, McCullin flew to Berlin during the building of the Wall and landed with only sixty dollars in his pocket. He had the mad guts to think that he could compete with the world's best in covering the event. He did, and won a contract with THE OBSERVER. Ever since then he has been a witness to the world's constant malignancies: Cyprus, the Congo, Biafra, Vietnam, Cambodia, Northern Ireland, Bangladesh. McCullin has become in a decade the recorder of man's inability to be man—or, at least, the exalted man he claims to be. Aptly, McCullin's first book is entitled THE DESTRUCTION BUSINESS. Some cannot look at McCullin's photographs. His only failure, he feels, is that still too many *can* look at them and still too many people *can* cause what he photographs. To Donald McCullin, his primary aim is to help put the Destruction Business out of business.

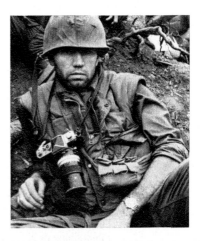

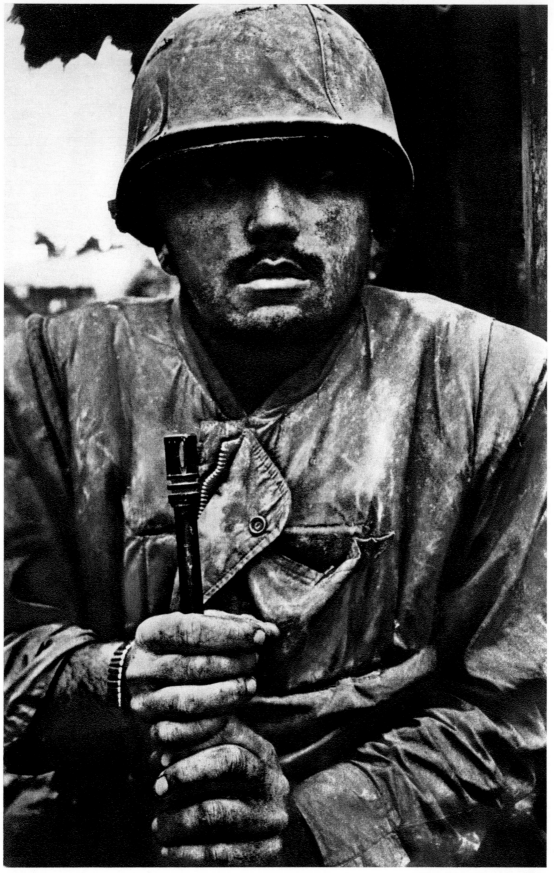

Hue, South Vietnam, 1968

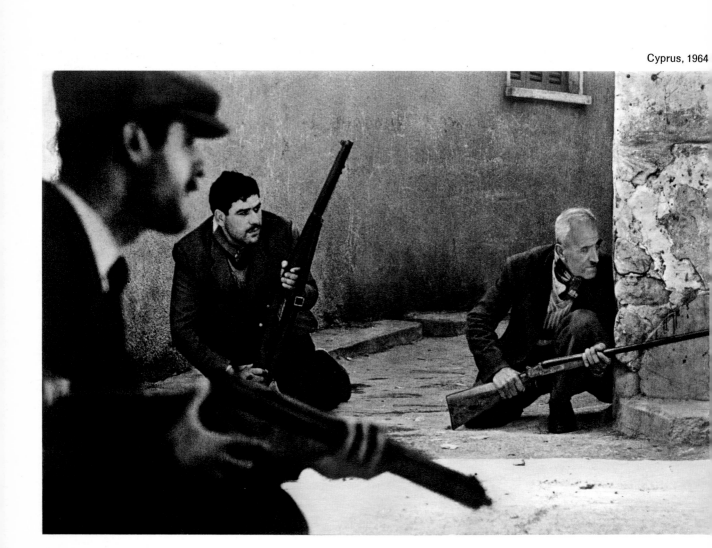

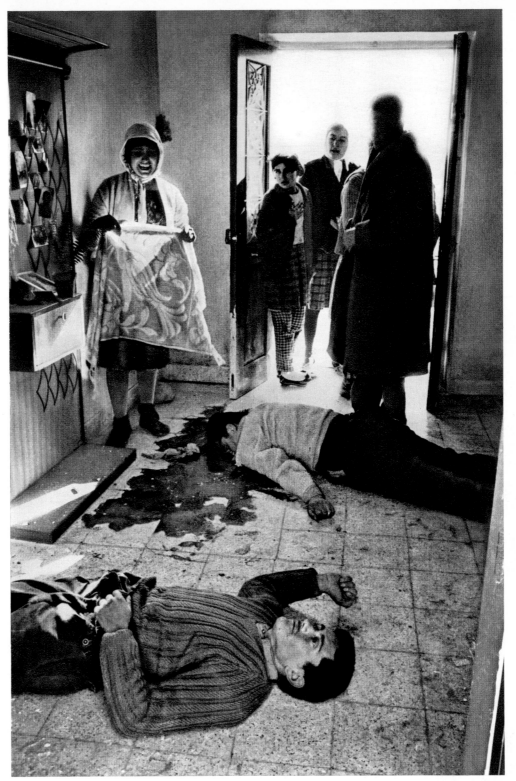

Cyprus, 1964

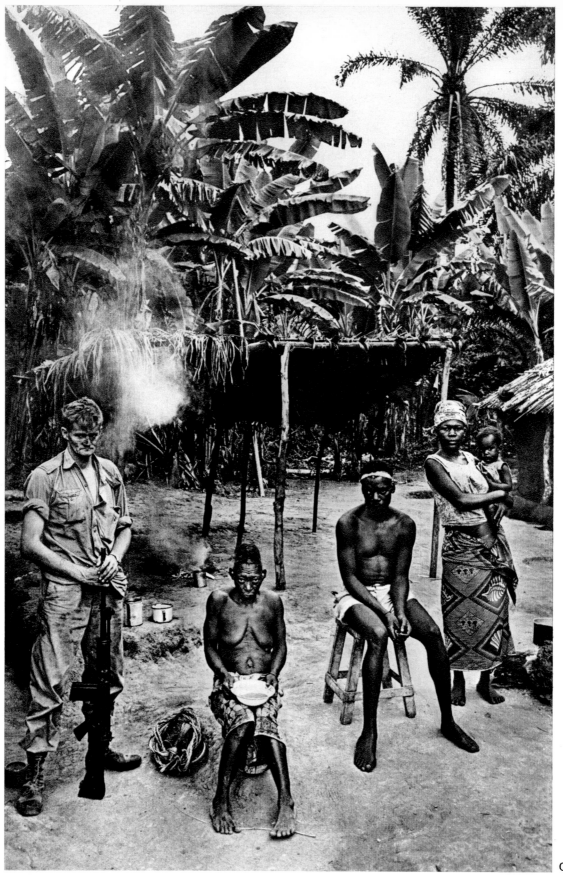

Congo, 1967

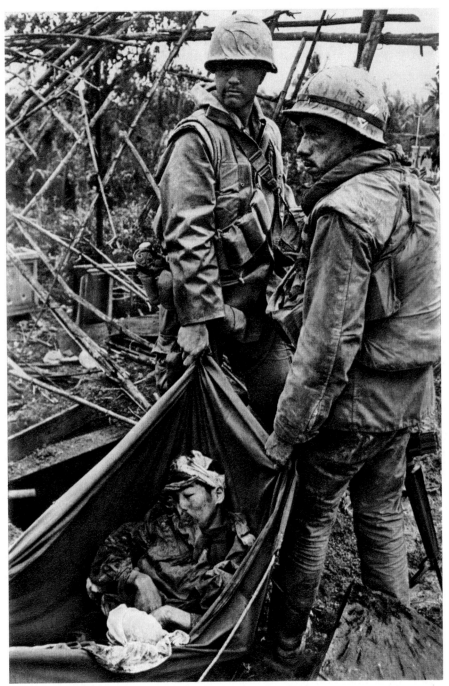

Hue, South Vietnam, 1968

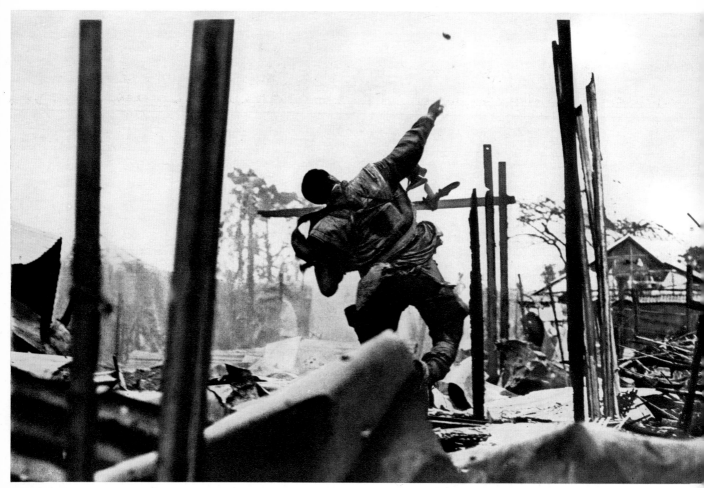

Hue, South Vietnam, 196

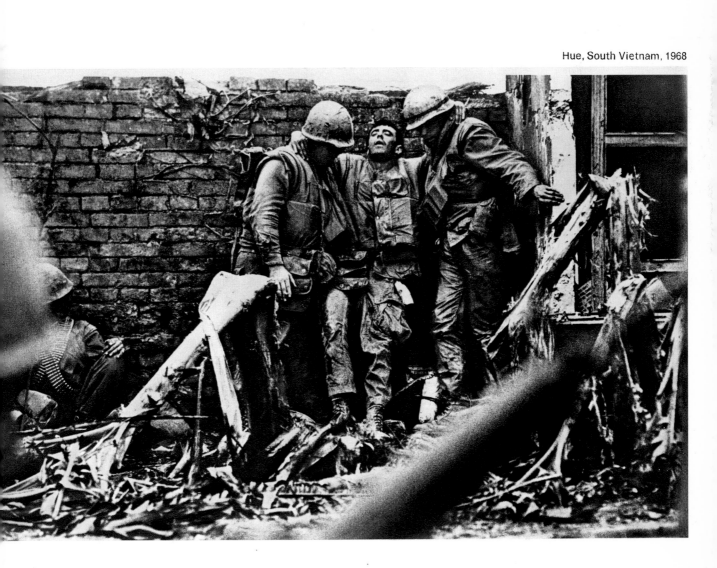

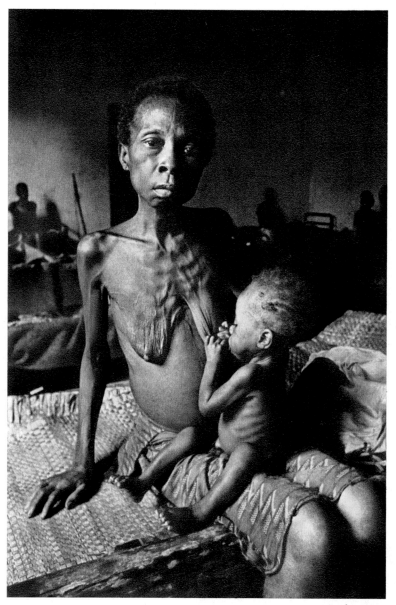

Biafra, 1969

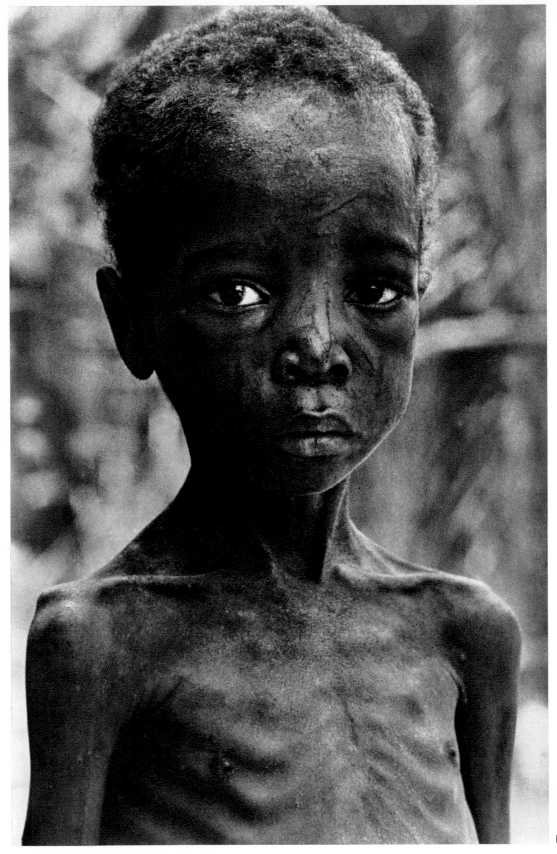

Biafra, 1970

Bangladesh, 1971

Bangladesh, 1971

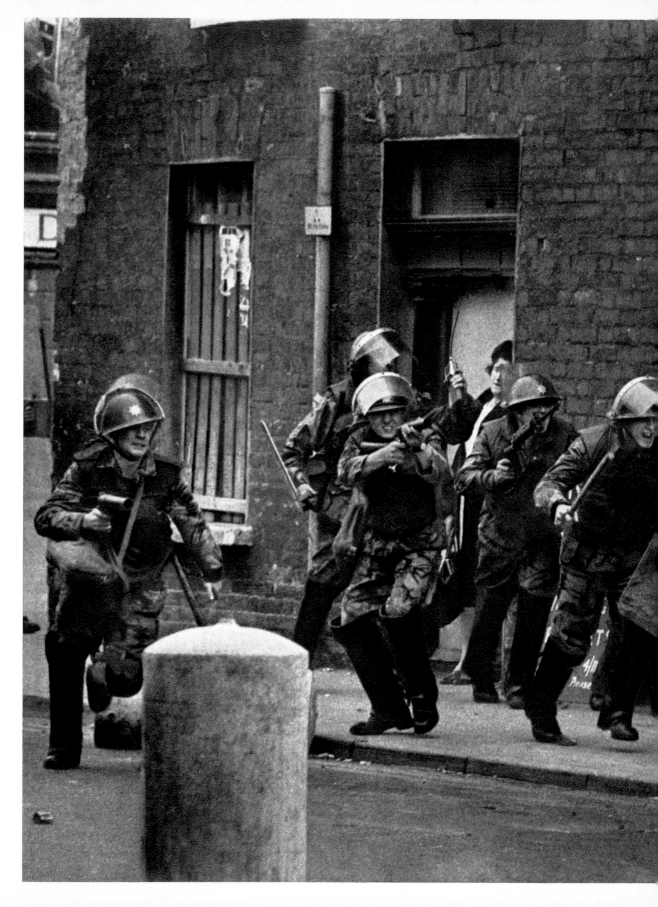

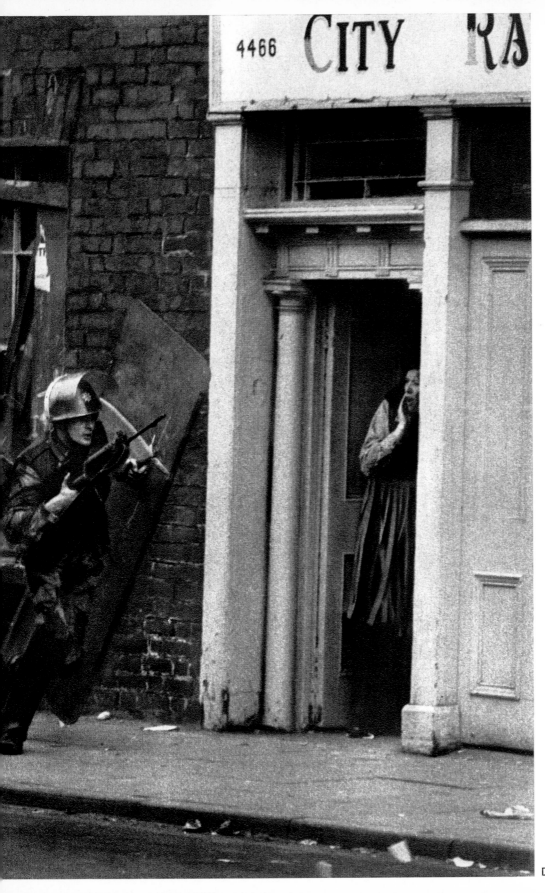

Derry, Northern Ireland, 1971

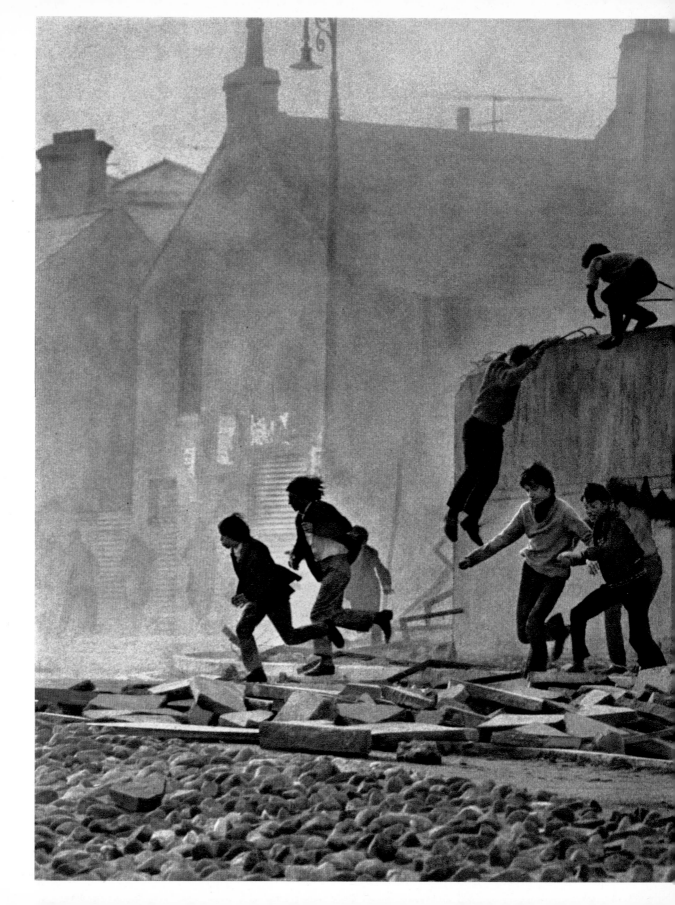

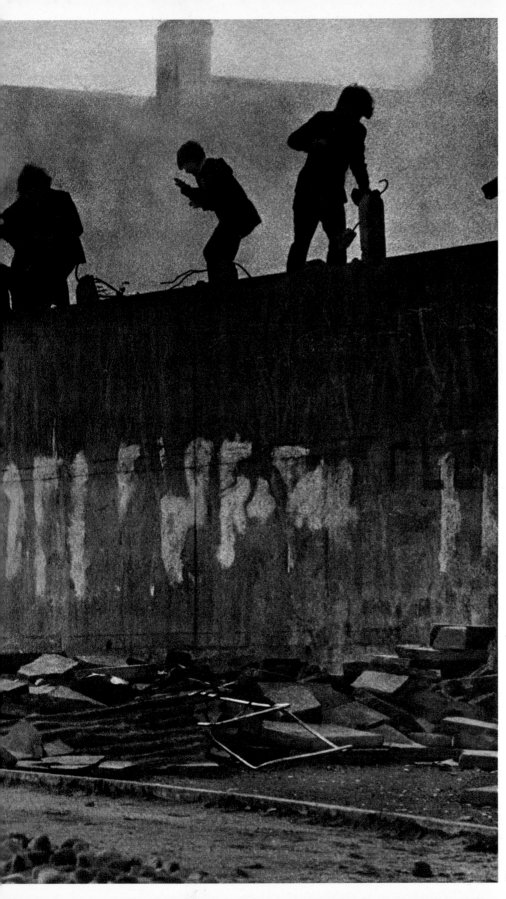

Derry, Northern Ireland, 1971

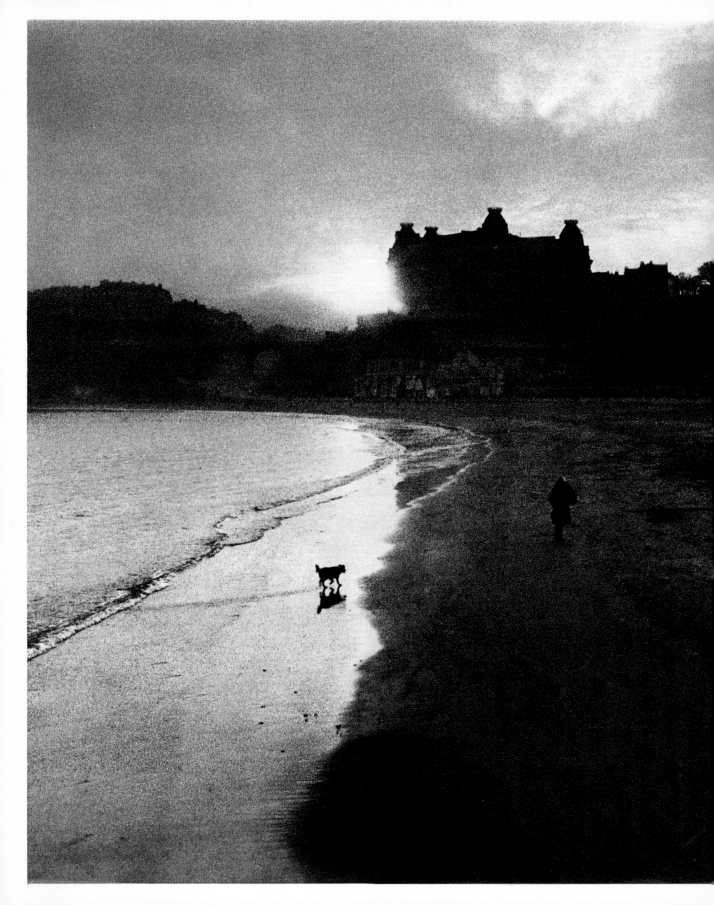

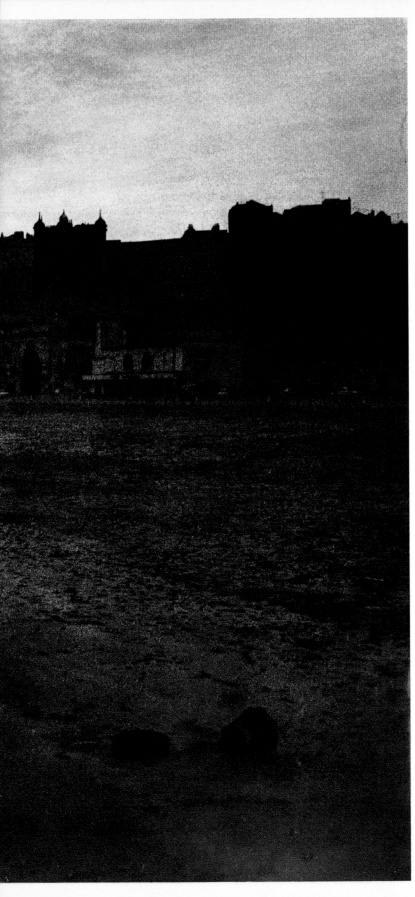

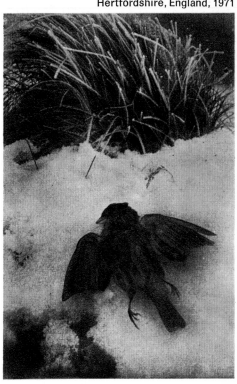

Hertfordshire, England, 1971

Yorkshire, England, 1968

W. Eugene Smith

"I am an idealist. I often feel I would like to be an artist in an ivory tower. Yet it is imperative that I speak to people, so I must desert that ivory tower. To do this, I am a journalist—a photojournalist. But I am always torn between the attitude of the journalist, who is a recorder of facts, and the artist, who is often necessarily at odds with the facts. My principle concern is for honesty with myself...."
—W. Eugene Smith

Life for W. Eugene Smith has been hard, and he would be the first one to admit responsibility for the heavy burden. He is, in some way, proud of his wounds because they seem to demonstrate that he has not given in to the easy, comfortable role of photographic success. Life is simply too serious; and Gene Smith is serious, too. Born in Wichita, Kansas, in 1918, his boyhood was shattered by the sensationalized death of his father: an event that made him eternally distrustful of journalists, not journalism. His genius glowed early, so there was no difficulty for others to recognize it. He had few problems securing positions at the top magazines—LIFE, NEWS-WEEK, and others. The problems, however, arose when the editors converted his vision into their own editorial viewpoints. This fanatical determination to remain steadfast to the truth as he, the photographer, saw it was both his stumbling block and his glory. Because of it, his personal life has been marred and scarred; but, also, because of it, Smith has been able to produce classics that have become legends in his own lifetime. How much poorer we all would be without *Spanish Village, Country Doctor, Nurse Midwife, Man of Mercy—Dr. Albert Schweitzer, Pittsburgh*, and all his other photo essays. Through all of Smith's images there runs a singular theme; his particular concern—the affirmation of life. It is the life's blood of his world that he graciously shares with us.

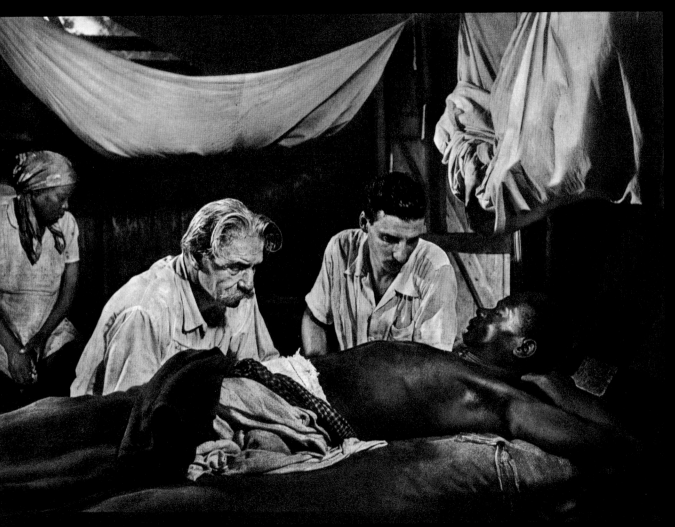

Dr. Albert Schweitzer, 1954

Minamata, Japan, 1972

Minamata, Japan, 1972

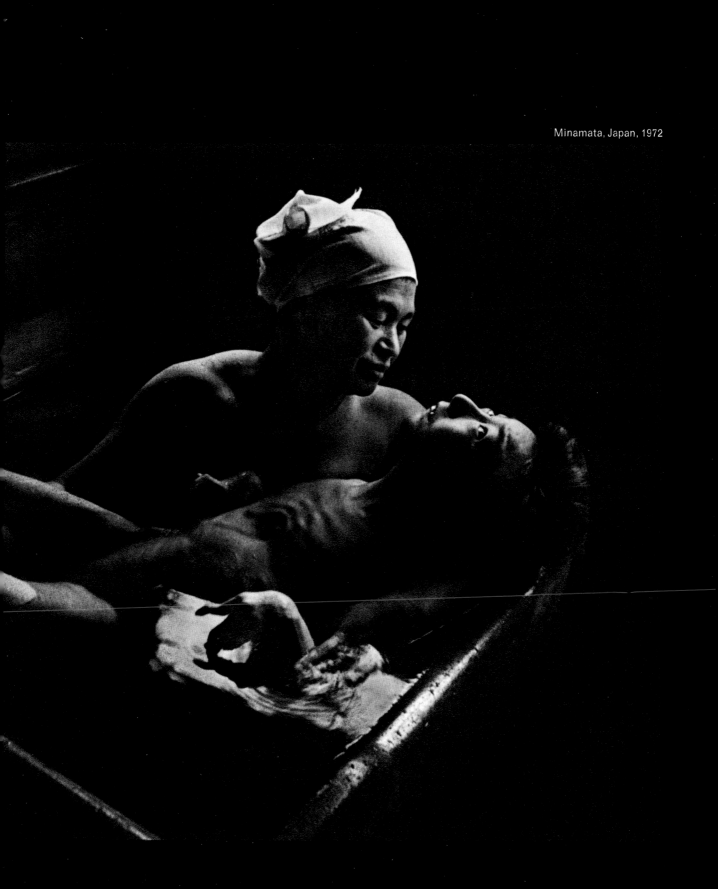
Minamata, Japan, 1972

U.S.A., 1953

Haiti. 1959

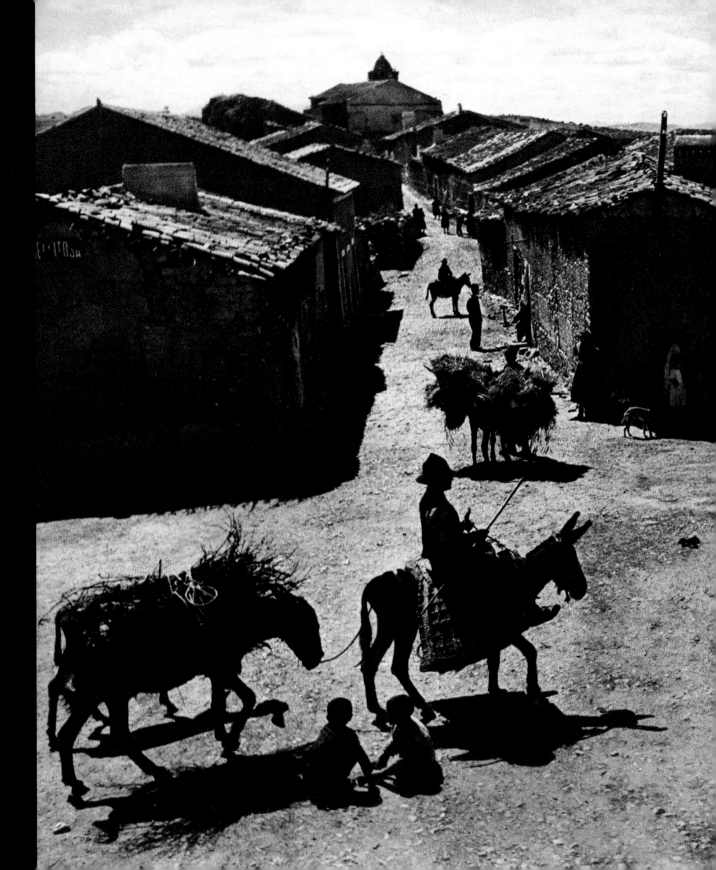

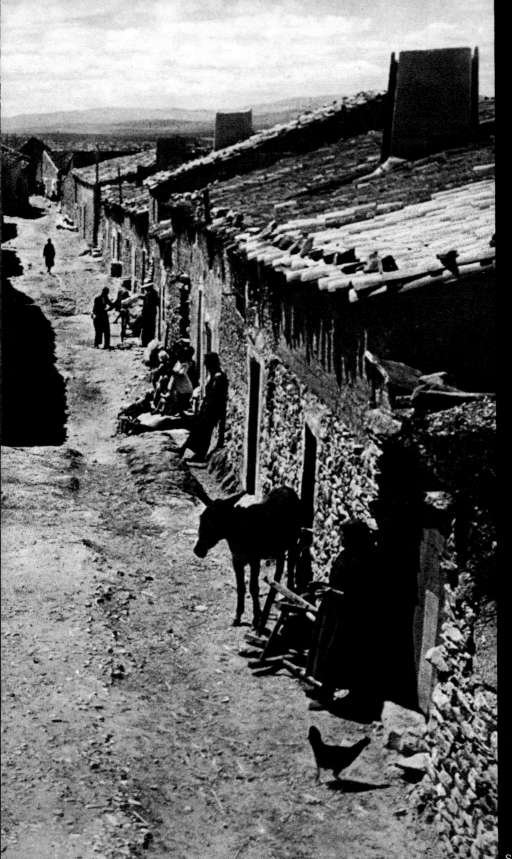

Spain, 1951

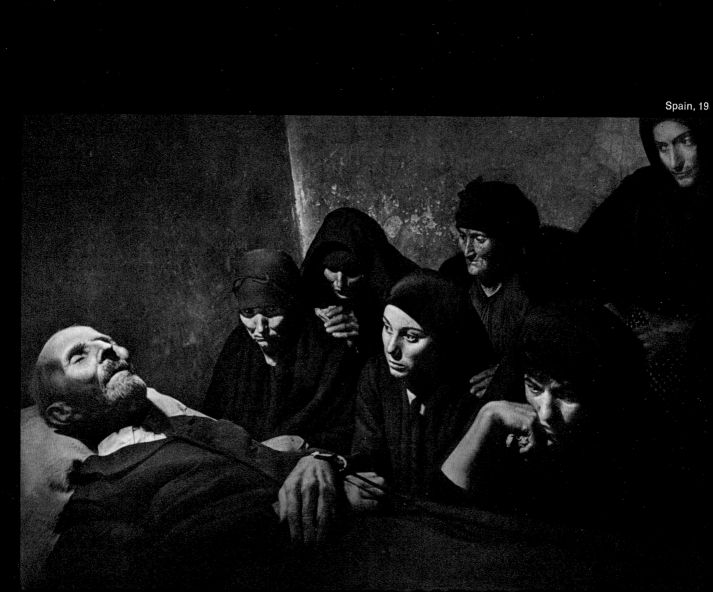

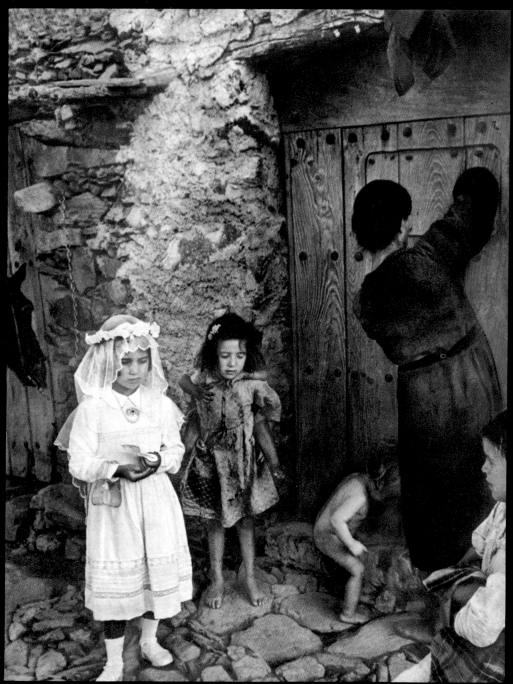

Spain, 1951

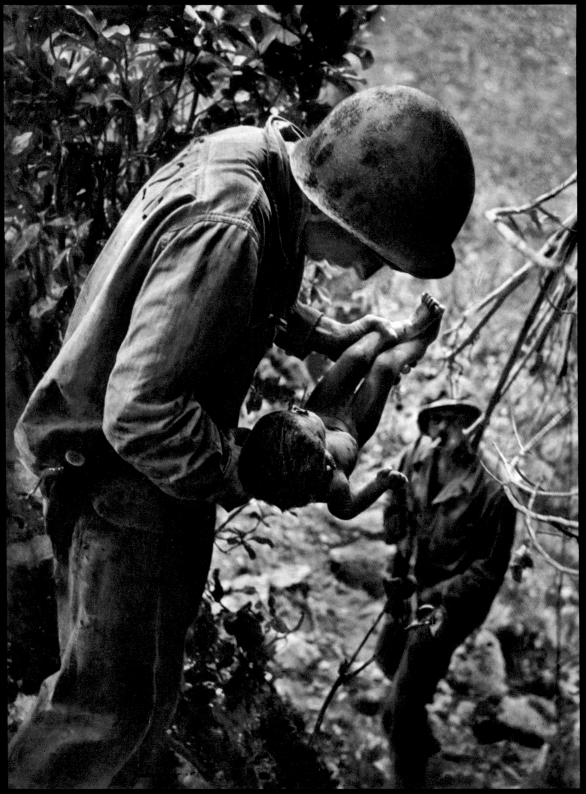

Saipan, 1944

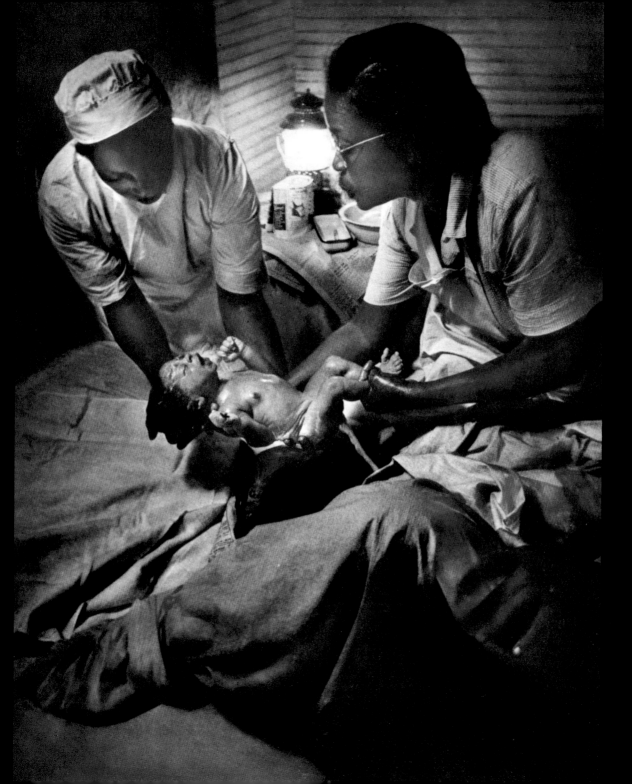

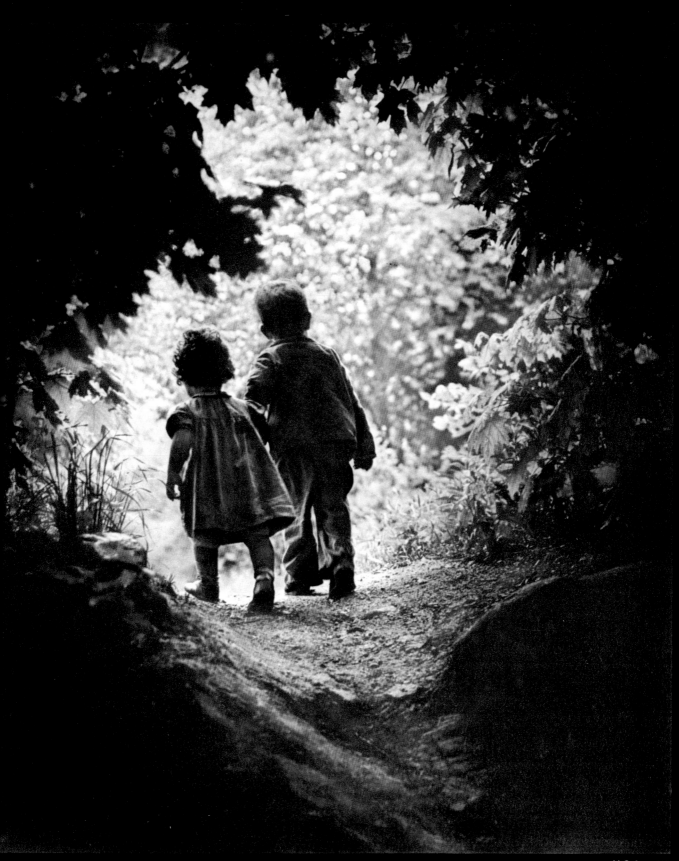

U.S.A., 1946

Marc Riboud

Chronology

1923
Born in Lyons, France

1950
Met Henri Cartier-Bresson

1952
Joined Magnum Photos

1954
Photographed Churchill, Conservative Party Conference, London

1956
Worked with Mike Todd in film *Around the World in Eighty Days*

1957
Went to China, covering stories on Peking and on Chinese industry and agriculture

1958
Completed stories on Pope Pius XII funeral; Rockefeller's election as governor of New York; and Sumatran rebels

1960
Photo-correspondent, Soviet Russia

1960
Two African trips to study Nigerian Independence Celebration

1961
Photographed in the Congo

1965
Photographed in China

1968
Photographed in North Vietnam

1971
Covered Indian-Pakistani War

1971
Made third photographic trip to China

Books

WOMEN OF JAPAN, London, André Deutsch Ltd., 1959

THE THREE BANNERS OF CHINA, New York, The Macmillan Company, 1966

FACE OF NORTH VIETNAM, New York, Holt, Rinehart and Winston, 1970

BANGKOK, London, Weatherhill-Serasia, 1972

Exhibitions

1967
One-man show, *The Three Banners of China*, Asia House, New York

1972
Behind the Great Wall: 100 Years of China, Metropolitan Museum of Art, New York

China, 1971

"The Great Wall is at this point sixty miles from Peking, and on this day there was a great mist. Chinese tourists, families, children, and officers are walking on the Great Wall, which is one of the favorite tourist attractions for the Pekinese on Sunday. On the right foreground is a Chinese boy, probably a technician or teacher or engineer, looking at his own camera, which is Chinese-made. Indeed, in China there is a great proletarianization—boy and boss and worker look very much alike regarding their clothes. But still one can see a distinction—he has a watch and slightly sophisticated glasses. He has this camera. And those signs would tend to indicate that he is one of these."

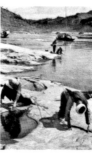

Chungking, China, 1965

"This is Chungking, on the shore of the Yang Tze Kiang, which is one of the two largest rivers in China. Nearly all of the communication between one part of China and the other is done by the river. The province of Chungking was not linked by road or railway to the rest of China—only by river. *Now* there is a railroad. Before the revolution, one could see all those boats pulled by men from the shore. I could still see it in 1957, but probably today this does not exist any longer. When I took this picture, the men explained that before the revolution, the rope around their bodies would cut into their skin. Now they have the 'comfortable' cloth harness. Also, the men are not barefoot—they are wearing sandals."

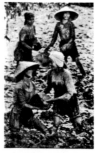

North Vietnam, 1968

"These women in the fields are digging out an irrigation canal that has been clogged with mud. This is a province south of Hanoi, and is Catholic. The women laugh because they work together and partly, I suppose, because I was there; they were probably joking. While digging here, they found an enormous unexploded 3,000-pound American bomb that had fallen a few months before."

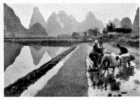

China, 1965

"This is Kwangsi province on the border of North Vietnam, in China, and it is near a place called Kweilin. These people are transplanting rice. You first plant the rice very close together and then move it. Those strangely shaped mountains are very particular to this part of the world. When this picture was published in a magazine, one reader wrote saying that the photographer must have faked it because that shape of mountain is geologically impossible. Actually, one is surprised by that shape there, because the rice paddy is very flat, and there is this extraordinary and sudden rise."

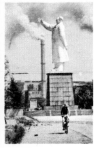

China, 1971

"This is at the entrance of a steel factory in Wu Han, a large industrial town on the Yang Tze Kiang. Throughout China, in front of factories, airports, schools, and public buildings, you can see big statues of Mao. Generally, they are white, and very often show his right hand pointing in some direction. On the pedestal is usually a saying of his. The smoke coming out of the factory is a sign of industrialization, of which the Chinese are proud. It is part of their pride in the revolution. However, the number of factories on the landscape is still very small. Industrialization is bringing so much good with it, for the Chinese at the moment—more than the bad that comes with it, such as our Western problems with pollution."

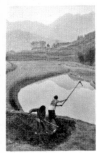

China, 1957

"This was taken on my first trip to China to the southern province of Szechuan, a very populated and fertile area. Every part of the land is cultivated. Two women peasants are hoeing a field which will probably be a rice paddy in the end. They have much humidity here and have two rice crops per year. You can see the dwellings for peasants in the background. They live much as they have before, but the way of working has changed—they now labor in teams and communes and the land is collectivized. What is probably true of these women is that they are working on the same land they have always been on, and this land their parents worked on, and those parents before them."

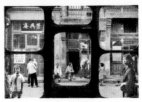

Peking, China, 1965

"The gold-lettered name of this shop means 'prosperity.' Private citizens come here to sell family jewels or other objects. The prices are fixed by the government. This scene has been photographed in old Peking through the window of a shop in Liu Li Chang, the street long famous for its art and antique shops. It is early summer and people live in the streets at this time. That's why you see women and old men and children. They live and play a lot in the street. And in the crowded streets it is very difficult to take pictures without everybody looking at you. When you keep walking, people are all around you, and as soon as you have your camera out, they gather around you."

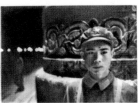

Peking, China, 1971

"This young soldier is of the People's Liberation Army, which is the Chinese Army, and he is standing in front of the main entrance of the People's Palace. This is one of the biggest buildings in Peking today. It was built in 1959 on the tenth anniversary of the revolution. It is all marble and stone. It has many huge rooms and reception halls, and a huge theater; also, there is an incredible congress hall that can seat 10,000 people. This is where the National Assembly meets. It even includes a huge banquet room where 5,000 people can eat at one time."

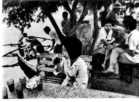

Hanoi, North Vietnam, 1968

"The bombing had just stopped over the north part of Hanoi, but it was still going on over the seventeenth and eighteenth parallels, the southern part of the country. Hanoi was free of bombs but the country still was under the state of war. There were many soldiers to be seen in the street. The main diversion on Sunday in Hanoi was walking around in the park and going on a tour with those small boats. The concrete benches date from the French occupation. The drinks were either some sort of iced tea or cool drink similar to orange crush. They also drink beer, some reasonably good locally brewed beer. I was not able to speak French to the young people, but only to some men older than forty-five—this meant they went to the University earlier than 1954, where they learned French—and they were very happy to communicate with me. I would meet them anywhere. They would talk about winning the war and then kicking out more foreigners from Indochina. They talk about this present war as the Second War of Resistance. (The first was against the French and ended with Dien Bien Phu in 1954.) And, in spite of that, they did not show any war reactions against the American people. They took great pains to explain that they were not against the American people, but against their American leaders."

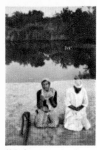

Dr. Roman Vishniac

Bangladesh, 1971

"Other journalists had many problems getting into the country. This was about a month before the war started between India and Pakistan; everybody was trying to go into the liberated area of Bangladesh. I got there with a small group of Westerners, taken by three or four Bangladesh boys from Calcutta across the river tributary of the Ganges by boat. For one entire day, from early morning until late at night, we walked in the liberated area. We walked to the front line, which is where the Bengals really were fighting against the West Pakistani troops, and then back to the border and the river in the evening. We came across these two Mukti Bahini doing their evening prayer. The landscape in the background is typical of this area. A lot of water everywhere, palm trees and jungles.

"They probably saw me first because it was getting to be very dark, and I had to shoot the picture at half a second. They went on doing their prayers and didn't do anything to show a wish to be or not to be photographed. Much of the problem in this part of the world is to take pictures; either they don't want to be photographed, or one is approached by fifty people who want to be photographed and want to look at the camera. But these men were in deep prayer."

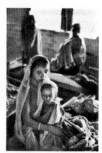

Bangladesh, 1971

"This is in a refugee camp on the border between India and Bangladesh. Several million refugees fled repression of the West Pakistani army. The people there had wanted to be independent from West Pakistan. These people were Bengali, and this woman has a very typical face. I took the picture in the hospital of the refugee camp; the child, as with so many I saw, has suffered severely from malnutrition."

Exhibitions

1939
One-man show, Louvre Museum, Paris
1941
One-man show, Teachers College, New York
1962
One-man show, *Through the Looking Glass,*
IBM Gallery, New York
1971
One-man show, *The Concerns of Roman
Vishniac,* sponsored by the International Fund
for Concerned Photography, Jewish Museum,
New York

Books

POLISH JEWS, New York,
Schocken Books, 1947
BUILDING BLOCKS OF LIFE, New York,
Charles Scribner's Sons, 1971

Chronology

1897
Born in Pavlavsk, Russia
1905
Began photographing
1906
Began photographing through a microscope
1914
Drafted into army
1915
First use of time-lapse cinematography
1914–1920
Sporadic study of biology and medicine at two
Moscow universities
1920
Left U.S.S.R. for Germany
1928–1933
Studied Far Eastern Art, Berlin
1933–1939
Filmed and photographed European Jews
1940
In concentration camp, Du Ruchard, Annot,
France
1941
Arrived in United States
1941–1950
Portrait photographer
1950
Developed new hypothesis of origin of life
1950–1960
Developed principles of rationalistic philosophy
1956
American Society of Magazine Photographers
Honor Roll
1960–1972
Developed new methods in microscopy

Films

1949–1972:
Life of the Pond
The Living Tide
The Edge of the Sea
The Standing Water
The Microscopic Algae
1968
The Big Little World of Roman Vishniac,
NBC-TV
1972
The Concerns of Roman Vishniac, ABC-TV

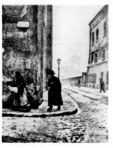

Cracow, Poland, 1939

"This was taken in the center of Jewish Cracow, where there
were three streets—Abraham, Isaac, and Jacob. The street here
is Isaac, and I was standing on the corner. At that moment, I had
the feeling that the centuries had moved backward; there I was
in 1500, and every man going by belonged to this time. After the
war, I was there once again; but the streets had different names
—no Abraham, no Isaac, no Jacob streets were left. No people,
nobody. Only the buildings stood where they were before. They
hardly looked different—maybe better, improved and repaired.
At that time, the Polish government wanted to have a 'cleanli-
ness' of Jewish life; and they did a good job for they have it now.
It was nearly absolutely cleansed of the Jews: what the Nazis
called *judenrein*. The Poles finished the job, but, when *I* took the
picture, it was a Jewish Cracow."

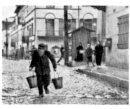

Lublin, Poland, 1938

"This could be an illustration of a Sholem Aleichem story taking
place in a different time. But it was taken in the thirties in the
time of the Free Republic of Poland; Sholem Aleichem set it dur-
ing the time of the Tzar, when Lublin was a Russian town. How-
ever, when I was there, everything was so different except for
the people, the suffering, the restrictions, the limitations—these
were still the same. The man is carrying water to apartments, and
in his job he must carry two pails filled to the brim up four flights
of stairs. And this was the only house in the neighborhood with
four floors. What is more, he was being paid so little for carrying
the water that we, today, could not even buy a newspaper for it.
Would you believe that the man was seventy-five, and that this
was the most important part of his life—to make money for him-
self and his old wife? He did it. He did it every day, from the
morning until the evening."

Cracow, Poland, 1937

"This man is wearing a hat with thirteen ends; it is the hat of the
Hassids, which is worn on the Sabbath."

Munkacs, Hungary, 1938

"There he is, the Rabbi of Munkacs, in the midst of examining and discussing the Talmud with his students. It is the evening after the Sabbath, and he is reading to them; they are listening very intently because he is a holy man. As you can see, the room was very, very dark. Luckily for me, a man who was passing through Munkacs had donated a very large wattage bulb for this special evening. It was a very expensive, strong electric bulb, and it could only burn for one hour. I knew I had only this short time. When I took this picture, it was a very important time in my life. This Rabbi was the only Jew whom Hitler decided not to kill. The Führer was told that this man spoke with God. Maybe the Rabbi did, and maybe the Jews were liars, thought Hitler. Anyhow, the Rabbi was considered a holy man, spared, and, in fact, he lives to this day in Israel."

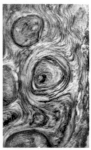

Warsaw, Poland, 1938

"The girl in the photograph with the flower on the wall was a pretty, sweet girl, but very unhappy because she had to spend the winter in bed. You see, it would have been foolish to buy shoes for a little girl when the money was so important for buying food or for buying shoes for those members of the family who could earn money. Her considerate father made paintings of flowers on the wall so that her winter in bed would be more pleasant. And these were the only flowers of her youth."

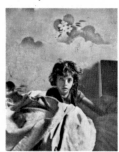

Human skin, 200 times, 1971

"This is a cross-section of my own skin. The magnification is 200 times and it was photographed with my own modified compound microscope. I used a color-saving process called colorization. You can see how beautiful I am—are we all not this way when one gets close enough?"

Carmel, New York, 1970

"This is early winter in our garden. And the length of the image, in reality, is just about two and one-half inches; that is why you see these beautiful snow crystals lying upon the gentle blades of grass. Does it not illustrate the universal beauty of the micro-world—that world that surrounds us and actually inhabits us—only we, man, do not find the time (God knows, we have the ability and knowledge) to see all this invisible beauty. We have only to look closer and we will see and discover. Beauty is everywhere. Nature is everywhere. We drown in beauty."

Anthrax bacillus, 2,250 times, 1971

"In reality, this is anthrax bacillus; but when I photographed it, I didn't think about the subject being a particular bacillus—I simply used the material. In other words, I used photomicroscopy, and, in using it, I am like a painter who gets ideas by just looking at the clouds. They speak to him and remind him of something. This anthrax bacillus spoke to me."

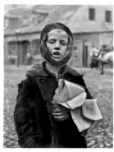

Slonim, Poland, 1939

"This is a young boy with a textbook. He is going home from school and he has a toothache. You can see how very unhappy he is; also, the book he is carrying is in very bad shape—very, very worn. I visited this town several times because my father was born there. And, especially to me, it was very interesting to photograph there."

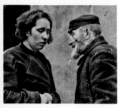

Lublin, Poland, 1937

"The hat that the man is wearing is typical of those found in Lublin, Warsaw, and other nearby areas. I should speak in the past tense—*was*. When I passed them, I overheard them speaking and I could hear her call him 'grandfather.' I did not know what they were talking about. However, my first thought was that they had a very difficult problem that needed an immediate solution. And seemingly it was just impossible for them to achieve this at that moment. I had a Rolleiflex under my coat—that was the only way that I could have gotten so close to them and maybe to their problem—if it was ever solved. I wonder. But, most important, I did not want them to know that I was there photographically eavesdropping on their lives. Also, it was important that the police not know about my activities with my cameras, otherwise, as before, I would have been accused of being a spy. I photographed in the secretive manner because most people want to look different—more important than they are, even better than they appear. This 'invisible approach' is the photography of natural reaction and the response that *I* want. The first condition is not to let the people know that you are taking the picture. You must take the picture as *it is*. And only then do you get a little piece of life. Maybe it is a happy expression, or maybe it is a sad expression—but it is a *natural* expression, and that is what I am after."

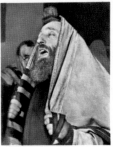

Germany, 1947

"This is a man who is remembering the members of his family after the holocaust of the camps, the war—after all that destroyed so much—all. It is the anniversary of the deaths of his wife and seven children. He was with them, but, God knows why, he was spared—by accident—and now I came in to photograph this tragic moment of remembrance, saying Kaddish for his forever-dead wife and eternally dead seven children. It was taken in a camp where the people could come and go, not a Nazi camp, but a detention camp where people remained until the time when Israel became a salvation and home. The people remained there in the camp after the war because they did not have any place to go. Then, suddenly in 1948, with the opening of Israel, the people left or were finally freed. So, now he, the poor/happy man is in Israel. That is the joy of life, I suppose, to remember the dead."

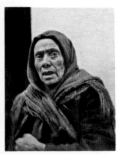

Lublin, Poland, 1937

"This is symbolic of a woman, an eternal woman who has tried to resist all the poverty, all the limitations and restrictions. She was searching for work, and it was very hard for her to find any. Her face shows us her energy in searching and the toll that time, under these conditions, has taken upon her appearance. She is much younger than the picture shows. At the time the photograph was made, would you believe that this woman was not more than fifty years old?"

Bruce Davidson

Exhibitions

1954
Brooklyn Gang essay included in inaugural exhibition Steichen Galleries, Museum of Modern Art, New York

1965
One-man show, *Photographs by Bruce Davidson,* Art Institute of Chicago

1966
Toward a Social Landscape, Eastman House, Rochester, New York

1966
One-man show, *Bruce Davidson: Photographs,* Museum of Modern Art, New York

1967
Photography in the Twentieth Century, National Gallery of Canada, Ottawa

1969
America in Crisis, Magnum-produced exhibit sponsored by ICP, in collaboration with Riverside Museum, New York

1970
One-man show, *East 100th Street: Photographs by Bruce Davidson,* Museum of Modern Art, New York

1971
One-man show, *East 100th Street,* Smithsonian Institution, Washington, D.C.

1971–1972
One-man shows (two), Museum of Art, San Francisco

Chronology

1933
Born in Oak Park, Illinois

1943
First became interested in photography

1953–1956
Studied photography, Rochester Institute of Technology, New York

1957
Studied philosophy and art, Yale University, Connecticut

1959
Became member of Magnum Photos

1959–1969
Photo essays appearing in the following magazines:

1959 RÉALITÉS (France) *Les Mauvais Anges de New York*

1960 DU (Switzerland) *Die Jokers*

1960 ESQUIRE *The Clown*

1960 ESQUIRE *Brooklyn Minority Report*

1960 QUEEN *The Teenage Jungle*

1967 LOOK *Power of Blackness*

1969 DU (Switzerland) *East 100th Street*

1969 LIFE *Gallery*

1962
Guggenheim Fellowship in Photography

1966
Photographed extensively, Los Angeles

1968
Began work on East 100th Street

1969
Received National Endowment of the Arts grant

1970
Completion and publication of EAST 100TH STREET

Films

Living Off the Land, American Film Institute, 1970
Zoo Doctor, CBS-TV, 1971
Isaac Bashevis Singer, 1972

Books

EAST 100TH STREET, Cambridge, Massachusetts, Harvard University Press, 1970

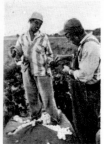

South Carolina, 1962

"I received a Guggenheim fellowship to travel and photograph in the South, and I spent several months there on my first trip in 1962. I came by a cottonfield and people were waiting for the farmer to weigh the cotton and pay the workers. I waited for the farmer to come. I asked if I could photograph him weighing the cotton."

Alabama, 1962

"I took this during the Selma march. I was told about a woman who lived nearby in a cabin. I went to see her and she invited me into her one room, with newspapers pasted on the wall to keep out the wind and a small log burning in the fireplace. She could not read or write and had never been to a motion picture show. She was living alone with the child. When you photograph under these conditions, the first thing is that you feel awkward intruding on a life: I might have been there for two hours, and yet I only took a few pictures. I had the feeling of almost walking into a Walker Evans photograph of the thirties."

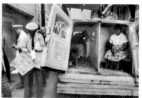

Birmingham, Alabama, 1962

"I was just walking around—one of the ways I try to cover something is to be there when no one else is or a year after something has happened. I flew three or four times to Birmingham and I stayed at the Gaston Motel. Dr. Martin Luther King was there and other leaders. That's the motel that later was blown up; in fact, my room was destroyed but fortunately I had left a few days before. I like to stay where things are likely to happen. By being close you feel the pulse and anxiety of a situation. They all had just had a demonstration at a lunch counter, and the sign says, 'Khrushchev can eat here, why can't we?' Afterward, the people would be locked up in a large jail for youth."

New York City, 1970

"I came to East 100th Street with view camera on tripod: I wanted to photograph in depth and detail and to meet the people eye to eye. I wanted to photograph without intrusion and to give prints to the people of the community—it's a personal view."

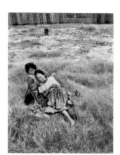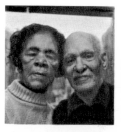

New York City, 1970

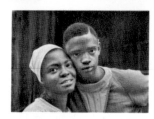

New York City, 1958

"There was a lot of teenage gang warfare in Brooklyn and Manhattan that I heard about, and I was attracted to the idea of photographing one gang. I found a gang in Brooklyn. They had just had what they called a 'rumble' and they were all cut up from this gang warfare. They wanted me to photograph their wounds for them, and I spent a year with them. Somehow or another, it wasn't the gang that was interesting to me. It was their isolation —their aloneness, their withdrawal from the people around them."

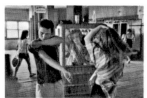

New York City, 1958

Actually the teenage gang essay is really not a clinical study of a teenage gang; it's a personal reflection. It's my exposure and my seeing myself inside that world."

Los Angeles, 1964

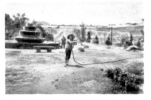

Gordon Parks

Exhibitions

1953
One-man show, Chicago Art Institute
1966
One-man show, Time-Life Gallery, New York

Books

THE LEARNING TREE, New York,
Harper & Row, Publishers, 1963
A CHOICE OF WEAPONS, New York,
Harper & Row, Publishers, 1966
A POET AND HIS CAMERA, New York,
The Viking Press, 1969
WHISPERS OF INTIMATE THINGS, New York,
The Viking Press, 1971
BORN BLACK, New York,
J. B. Lippincott Company, 1971
IN LOVE, New York,
J. B. Lippincott Company, 1972

Films

Flavio, documentary, 1962 (Director-Writer)
The Learning Tree, 1968 (Director-Writer-Composer)
Shaft, 1971 (Director-Writer)
Shaft's Big Score, 1972 (Director-Writer)

"I like space, but I don't like sunshine, and there's always sunshine there and you're always sort of squinting at something in the distance. This was a housing development. The fountain is at the entrance to the garden or whatever it's called—the entrance to the huge tract. I had an eerie feeling, conscious or unconscious, uncanny, that makes you react to something. It was very desolate there: really dry and hot. It seemed sort of futile then for that woman to be putting the water in the ground."

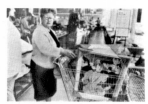

Los Angeles, 1964

In a supermarket.

Los Angeles, 1964

Ordering food through a microphone.

New Jersey, 1958

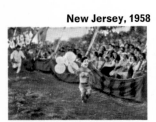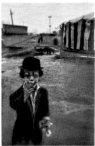

"The circus was at Palisades Amusement Park, across the Hudson River in New Jersey. I went there one afternoon and I met Jimmy, who is a dwarf and works as a clown. We've corresponded now for over ten years. The way I get in touch with him is that he'll send me his itinerary. And this will say he's in Grand Rapids, Michigan, and I'll call the chief of police there, who'll go out in a squad car and give Jimmy a note. He's still with the circus. I saw him as a terrific person, sensitive to others. He has a good view of life, and enjoys his work—a real artist. He invented his own acts and would work on them hard. He was also a very lonely man. Circus life is a very beautiful life, but the world of the tent is very hard. The people are very involved with the circus."

Chronology

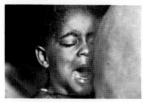

New York City, 1968

"She's one of the Fontenelle children, and she's crying because one of the kids hit her in the face. The point is that the father had lost his job, and there was a great deal of animosity and violence among the kids because of this. What's more, the father was beating up the mother. That was part of the whole thing. You see, in these poor struggling black families, the father cracks up on the job, and the mother and father begin to have problems which go all the way down to the kids."

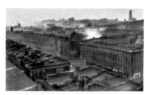

New York City, 1948

"This is the first story I did for LIFE magazine, and it dealt with the subject I knew so well—Harlem."

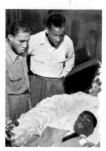

New York City, 1948

"i wanted to do a gang story, and had a friend who was the captain of the detectives. When I told him that I wanted to do a thing on gang leaders in Harlem, he told me it would be like looking for a needle in a haystack. And just about that time, as he told me his discouraging opinion, he said, 'Here's the top one, coming in right now.' And there were three coming in—the one you see in the coffin, Red, and another. They don't know who got him, but there was a rival gang—in fact, there were three rival gangs at the time. His face was all scarred up—they have a lot of makeup on him."

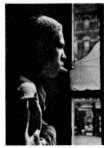

New York City, 1948

"That's Red Jackson, the leader of the gang. He is the one I ran into at the precinct house. He came over to me and asked me what I was in for. I told him who I was, and approached him on the Harlem Gang story—he refused. We went outside, and at that time I had a big new Buick and Red's feet were hurting. And that was the one thing that got me that close to him—I gave him a lift home. At first he refused the ride. Then he said OK. Much later, he said I could come to them—it was a matter of winning their confidence...hanging around with them, giving a guy a buck if he needed it. They know you're trying to soft-soap them, so you give them a buck and then you say, 'Yeah, man, I got a buck, but I want my buck back.' You know you'll never get it back, though."

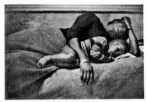

New York City, 1968

"This is Mrs. Fontenelle and one of the kids, and it's one of those times when the tension of living just got to them. The tension there came when the husband lost his job, and money and food were short. I remember Colin, one of the boys, was having problems in school. The old man got half tight one night and locked him out in the cold...and that's where I found him. So I asked him if he wanted to come with me. He said no—his mother would get him back in. The old man began to beat up on her. She decided to scald him with hot water, and she even put honey into it so that it would stick. You may think and say that it was a terrible thing to do, but there's a woman with all these children, and she's struggling to keep them alive and clothed. It was a desperate action."

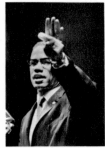

Malcolm X, 1960

"There he is, Malcolm X, making that gesture of his—the hand just like that—at a Muslim convention in Chicago. As you know, he really had a way with audiences. I traveled around the country with him, and we became very, very close. In fact, I am the godfather to his child; his wife and I are very good friends. I think the movement had a tremendous loss in Malcolm's death—more than it realized. The people in the movement are getting along, they're prospering; but not at the clip they were when Malcolm was around. He was a great strength to them."

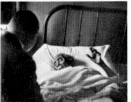

Chicago, 1950

"This was on the North Side of Chicago; the story was about a minister—how he ministered to his flock, to get them pacified enough to go out and back to work. He was a psychiatric crutch to these people. They were just so beat up, it was dangerous for them to go back and work; they were just shaken down, mentally and morally. I never quite looked at a minister like that before. It's not saying that we need spiritual help, because next week is going to be bad. It's preparation to go back out and face the world."

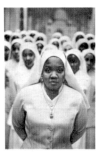

Chicago, 1960

"That's Elijah Muhammad's daughter; her husband is the head of the Muslim Guard, called the Fruit of Islam. The Muslim women are good housekeepers and very subservient to the men. They are handed down the law of Elijah Muhammad and they have a complete respect for the man. No question. They are affected very little by women's lib. I was the only person ever allowed to photograph them within the confines of their mosque, or building. It was a matter of the confidence that Elijah Muhammad had in me that I would not betray them in any way. It took me two or three times with Malcolm before I could even get in there. Then, after that, they still checked me a lot. They couldn't believe that Elijah Muhammad would let anyone in. They were very suspicious people, and were having a lot of trouble with police shooting at them...maybe they thought I was a detective or something. They shake everyone down. Even a brother like Muhammad Ali."

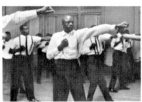

Chicago, 1960

"These are the Fruit of Islam. They have tremendous discipline. For example, I remember once when one of them did something physically wrong, he was made to do one hundred push-ups. He did them and didn't grumble about it! This discipline does them a lot of good—a lot of them were on dope, and a lot of them were whiskey heads. They all have those shined shoes and those white shirts, and that's their life. Their salary goes to Elijah Muhammad. You can ask, what makes a man do that sort of thing? And you only have to remember that these people have been ostracized absolutely by society. There they are, ' the scum of the earth ' and then a man comes along and tells them they have their pride, their own mosques—and suddenly they are someone important. They're trained to protect themselves—karate and all that stuff. They don't trust what they call the 'blue-eyed devil,' and that goes for the blue-eyed black also."

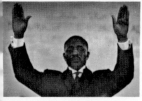

Chicago, 1950

"There he is, that minister at the North Side of Chicago, at Sunday service in his church. He had a great strength; bought this church on the North Side, and gave his strength to the people who needed it most. I was on the LIFE staff when I shot that photograph, but I traveled alone and won their confidence. They were, in a sense, as strict a cult as the Muslims, and they were very beautiful."

New York City, 1950

"This is Harlem, and to me it shows all those fears people have, all mixed-up. You have religion, the occult, magic—anything and everything to make life easier."

Rio de Janeiro, 1961

"The important thing in shooting the story about the Favela was to establish a rapport with Flavio's family. With the Fontenelle family, it was three or four days until I took out a camera. I became involved with *their* problems; watched them and helped if I could. I talked to the kids a lot. They begin to trust you, and, after a while, there's nothing you can't get that you want to get. There are some things you don't want, because you feel that you're intruding too much on their privacy. But in the case of Flavio, this was the family being in need, a friendship and understanding. I had a fancy hotel down in Rio, but rather than stay at it, I slept with Flavio and his family, with the bugs and on the floor, for about three months. My editors in New York got worried; they simply didn't know where I was, and they couldn't track me down. I had disappeared in the hills and everyone knew it was dangerous up there. I just became so involved with the story and in Flavio, I had forgotten that there was a LIFE magazine or anything. They did send some people up there, looking for me; and I came down and cabled my story to New York."

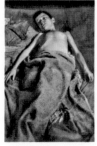

Rio de Janeiro, 1961

"Flavio was ill most of the time. But he had this great will to keep going. Some days he'd just become so weak, he'd just lie there and wheeze. He had bronchial asthma, tuberculosis, and malnutrition. Later on, because of the story, he was brought to New York and cured. Now he works in a machine shop. Some money was set aside for him, and he'll get it shortly when he's twenty-one."

Rio de Janeiro, 1961

"That's a Negro who died. They put candles out, if they have them. They take out a clean sheet, if they can find one. They use incense, if they have any. He's been there like that for thirty-six hours because the undertaker couldn't come—he was off on vacation. So what they do is get a sheet from a neighbor and they just stretch him out like that, and tie his head together to keep his mouth shut. He was twenty-two years old. It's the fortunate ones there who die young."

Ernst Haas

Exhibitions

1947
One-man show, *Homecoming of Austrian Prisoners of War*, Vienna

1962
One-man show, *Ernst Haas: Color Photography*, Museum of Modern Art, New York

1962
Participant and editor, *The World as Seen by Magnum Photographers*, Pepsi Cola Gallery, New York

1964
One-man show, *Poetry in Color*, IBM Gallery, New York

1968
One-man show, *Angkor & Bali: Two Worlds of Ernst Haas*, Asia House, New York

1971
One-man show, exhibition of photographs from THE CREATION, Rizzoli Gallery, New York

Books

THE CREATION, New York, The Viking Press, 1971

Chronology

1921
Born in Vienna

1947
Homecoming published in HEUTE magazine

1949
Became member of Magnum

1952–1960
Photo essays appearing in following magazines

1952, LIFE, *Land of Enchantment*

1953, LIFE, *Images of a Magic City* (New York– 2 parts)

1955, PARIS MATCH, *Asia-Africa Conference, Bandung, Indonesia*

1955, LIFE, *The Glow of Paris*

1955, ESQUIRE, *Glass Canyon: New York City*

1956, LIFE, *The Mirror of Venice*

1956, HOLIDAY, *Angkor*

1957, LIFE, *Beauty in a Brutal Art*

1958, LIFE, *The Magic Color of Motion* (part 1) *Adventure in New Camera Realm* (part 2)

1959, ESQUIRE, *Bali*

1960, HOLIDAY, *Norway*

1958
Voted as "one of world's greatest photographers" in POPULAR PHOTOGRAPHY poll

1958
Recipient of the Newhouse Award

1962
NET-TV, *The Art of Seeing*, series of four thirty-minute programs

1972
American Society of Magazine Photographers Honor Roll

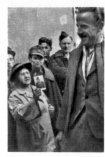

Vienna, 1947

"A woman has the picture of her son in her hand and shows it to a returning prisoner of war; and it is the typical, also human, way that the soldier is so glad to be home and doesn't want to look at the picture, just passes by and goes home. And it's the typical Viennese woman—a little fat, with a little hat on, and I can see her apartment exactly, looking into her face.

"We have a proverb in Vienna that says, 'If the devil wants to torture you most, he lets you wait.' It's always the woman on the home front who doesn't know and suffers from not knowing.... I had tremendous empathy for them. And, after the war is over, they had to wait another two or three years. They didn't even know if the man is coming with the transport. The children grow up and the mothers give them pictures of their husbands that don't look like them anymore...they all stand and they ask, 'Have you seen this one?' and they went, for instance, to this homecoming prisoner train fifteen, sixteen times. Each one has the hope—maybe he comes. Maybe they haven't heard from him for four years, five years. And this, I think, is the most inhuman torture there is."

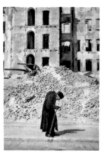

Vienna, 1947

"This is one of my first published photographs. Previously, I had photographed abstractions, flowers, and when the war was over I had my first opportunity to show my pictures in Switzerland, which was a neutral country. For the first time I could find out how it was to live in peace. I went there and was brought by a friend to Arnold Kübler, who was then Bischof's editor from DU magazine. A fantastic kind of a man; he looked at these pictures and said, 'I can't understand it. There is a man who is in the middle of history happening around him, and he photographs flowers and walls and so on.' I said, 'But maybe I can understand it. Maybe it's a defense mechanism.'

"He said, 'The other thing is so normal for him that it is like our streetcars, and we wouldn't photograph our streetcars. Maybe it's good for you that you came to Switzerland, that you see how boring it is when you live a normal life. Now when you go back to Vienna, you will find out what an incredible heaven you have for a photographer.'"

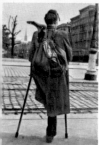

Vienna, 1948

"But then, you see, we are all glad—now he has been home. When he comes back, there is the incredible embrace and everybody's so happy for them; and what happens then? This becomes the biggest tragedy. A different man came home."

U.S.A. 1960

"When John Huston directed the film *The Misfits*, he asked Magnum photographers to photograph the production; each photographer could pick any subject matter, and most chose the famous actors. I said I would like to do something on the mustangs, which were always close to me. This was about eleven years ago. Thus, I spent most of my time with the second unit, which was filming the breaking-in of mustangs; that's what the whole story is about. And they—the horses—are as much misfits in our society as all the people who are hunting for them. And that was, I think, the parable and moral of it."

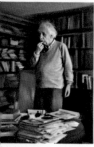

Albert Einstein, 1952

VOGUE magazine asked me, after I had photographed George Bernard Shaw, to also do Einstein. So they sent me with a young philosopher to Einstein at Princeton University, and Einstein was incredibly aware of the camera. He always was posing and looking at my camera and I *never* could get the picture I was looking for, just a second of his being unaware. Also, on top of this, the editor wanted to have a picture of Einstein thinking...so we went to the library and we were speaking German, talking about Vienna and Viennese writers, and I said that a certain famous Viennese writer had just come out with a history of culture, a three-volume book, that was very, very fantastic. He was standing there in front of his library, and I said, 'Do you have the book?' and he said, 'Let me think, where did I put that book?' and finally, I got a picture of Einstein thinking!"

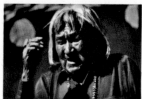

Hopi Chief Dan, 1960

"You can learn so much from the Indians. The wonderful thing is that one can learn without real school learning. I don't want to seem super-spiritual, but the wonderful thing about Indians is that you can be quiet with them. And you can learn a lot from people who are completely quiet. You see, this is the same thing with seeing. It's a sense which is still, but if you know how to see, and you look into somebody's face, you can read their character. You don't really need any kind of words, and I think with the Indians it's the same kind of stillness. They kind of sit there, and you learn something in the same way that you learn when you meditate."

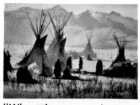

Canada, 1970

"When they were shooting the film *Little Big Man,* I spent time with the Indians. An incredible thing happened—almost as if the clock had been turned back to the time when the buffalo were plentiful and were the mainstay of the Indians. This photograph was taken on the reservation of the Sarcy Indians, who played a part in the movie. They used to live in buffalo-skin tepees, but during this century they moved into huts when the buffalo were killed off. For authenticity, the film's producers acquired possibly the last large remnants of buffalo skins, so that the Indians could live in tepees. Just a few days after they moved in, it was as if they had never left this way of life. And this is what I captured here. They would socialize around the fires in the snow, sitting on fur rugs and enjoying it very much. It will probably never happen again; it was absolutely genuine."

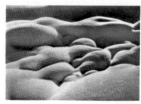

Aspen, Colorado, 1970

"In order to have a consciousness that can appreciate nature, you have to create man. We really went from one consciousness notation to another. First you have crystallization; then plant life, which moves after the life and light; and then animals, which can change their place; and it got higher and higher. The whole earth was covered with plant and animal and mineral life, but still there was not a consciousness that said, 'Oh, this is beautiful, I appreciate it; I am aware of it.' So once more there was a jump in the consciousness and man was created. And it was an incredible jump, because people always say we come out of the animal. Of course, we come out of the animal. But there is much more than the animal, because within us is something really far beyond the animal. An animal has to say 'yes' all the time to nature, and we, for the first time, could say 'no.' This is the difference.

"The snow looked like human forms. And I took this picture because I believe that nature, in its long, long way, really prepared itself for man in many, many ways. And in that way the human form kind of started to grow gradually and came out here

and there, and all the ideas which it took to make men were all tried out before in the world. The elements are within us, and the idea of the tree is within us as much as one can find a human figure in the snow."

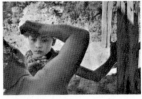

Bali, 1956

"The photograph was taken of a young girl being prepared for the ceremonial dance. The Balinese are super-sensitive people, super-sophisticated. They are almost chic, to a degree that a lot of the men are homosexual, because they are overaesthetic. They are so over-cultured, and they are so over-danced—music, and mysteries, and all those sorts of things. There's a super-sensitivity in it. And here I tried to show that super-sensitivity as the young Balinese girl is being carefully prepared for the dance."

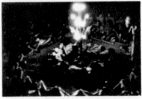

Bali, 1956

"Look at that contrast—the beautifully sensitive-looking girl and this extraordinary ceremony, the Balinese monkey dance. It's called the Ketchak, which comes from the incessant sound made during the ceremony. It's the old, old story of when man used to have to fight the monkey armies. They used to have it in Hindu. This is a Hindu island, and this is part of what is left over. I believe the circle is the symbolism of the earth."

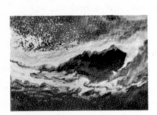 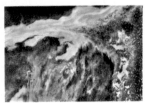

Los Angeles, 1971

"This is a paradox, because I found a polluted river which, by the design that the pollution brought out, made incredible kinds of abstractions; and, in many ways, very, very cosmic kinds of pictures were produced by this diseased river. I looked and I photographed and I photographed—all in black and white—and I saw within the river things that really had nothing to do with pollution. It could be a tremendous big wave; and it really looks as if it would be tremendous motion. It isn't. It is something that moves very, very slowly in this strong universe of a polluted river."

Hiroshi Hamaya

Exhibitions

1946
One-man show, *Document of the Heavy Snowfall in 1945 in Takada, Niigata-ken*

1947
One-man show, *Seven Artists in Echigo*

1957
One-man show, *Red China I Saw*

1959
Internazionale Biennale di Fotografia

1959
One-man show, *Oak Dit is Japan,* the Netherlands

1960
Magnum's Global Photo Exhibition

1960
One-man show, *The Document of Grief and Anger*

1965
12 photographers: *An International Exhibition of Contemporary Photography,* Gallery of Modern Art, New York City

1969
One-man show, *Hamaya's Japan,* Asia House, New York City

Books

SNOW LAND, 1956

JAPAN'S BACK COAST, 1957

URUMCH-HSINCHIANG, CHINA, 1957

RED CHINA I SAW, 1958

A VOLUME OF SELECTED WORKS OF HIROSHI HAMAYA in the series of CONTEMPORARY JAPANESE PHOTOGRAPHY, 1958

CHILDREN IN JAPAN, 1959

THE DOCUMENT OF GRIEF AND ANGER, 1960

DET GOMDA JAPAN, Bonniers, Sweden, 1960

LANDSCAPES OF JAPAN, 1964

AMERICAN AMERICA, Kawade Shobo, Tokyo, 1972

Chronology

1915
March 28, born in Tokyo, Japan

1931
As a souvenir gift from a foreign trip, hand camera was given to him by father's friend; took first photograph

1935
Bought a Leica; devotedly took photographs of downtown Tokyo

1936
Photographs were published for the first time in a journal

1937
Became a free-lance photographer

1939
Visited snow country for first time; became very much interested in folklore

1940
Visited a small village of Niigata Prefecture and began to take documentary photographs using folklore theme, continued for ten years; became a book SNOW LAND; visited Manchuria

1942
Again visited Manchuria

1945
After Japan's defeat, changed residence from Tokyo to Takada City, Niigata Prefecture

1948
Married

1949
Returned to journalistic work

1952
Changed residence to Oiso, Kanagawa Prefecture, near Tokyo

1954
Started to take photographs for JAPAN'S BACK COAST

1956
Traveled throughout China for forty-five days

1960
Visited Thailand
Took photographs of demonstration against Japan's political policy and became contributing photographer to Magnum Photos. At same time, began photographing Japan Archipelago

1963
Visited West Germany to photograph on assignment The Working German by request of West Germany Second Television Society. Also visited France and Switzerland

1967
Visited U.S.A., Mexico, and Canada for three months; traveled around the 35 States (17,432 miles) in seventy-one days. Saw the land of America from "Point of Nature and Human Being"

Japan, 1957

Portrait of a dancer from the Ryukyu islands.

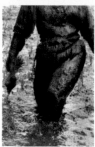

Toyama, Japan, 1957

"The rice-growing method used in this area is very different from that of other districts. The woman is wearing ragged clothes and the rope attached to her is a sort of lifeline, so that when she steps into the mud up to her chest, she avoids any accidents in case she slips and falls. They wear the rags to protect the body from any abrasions caused by the rope."

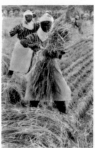

Yamagata, Japan, 1955

"The farm women are reaping the rice harvest. In this area, the farmers are specialists at a particular method of growing rice and have about one crop a year."

Hokkaido, Japan, 1957

"Spearing fish during the winter is one of the ways the people of this area acquire the mainstay of their diet."

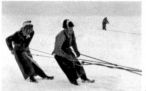

Akita, Japan, 1956

"This is how the people in this area ice-fish with nets during the winter. Each person who lives by the shore is half-farmer, half-fisherman. In the winter, when the lake is frozen, they fish in this manner."

Aomori, Japan, 1955

"A farmer's baby is sleeping under a mosquito net in one of the baskets that is typical of this area."

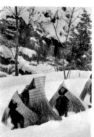

Niigata, Japan, 1956

"Children in the snow country on their way to a January festival."

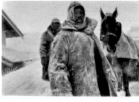

Aomori, Japan, 1955

"In the Tsugaru district, the winters are very long. The people cannot spend the winter playing, and even when the weather is very bad, they have to go out and work. At wintertime, most cars and trucks cannot be used, so the people rely on horse-drawn sleighs to carry the lumber."

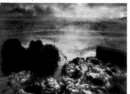

Tojinbo, Japan, 1960

"There are enormous differences between the coasts of Japan facing the Pacific Ocean and the Japanese Sea, the rock formations being one. On the coast of the Japanese Sea, there are many igneous rocks and the color of the stones is almost black, making for a very dark and ominous seashore."

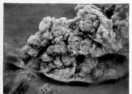
Hokkaido, Japan, 1962

"When the thunder storms and lightning crosses. The smoke of the eruption covers part of the sky, blocking the sunshine and resembling a thunderstorm of madness. That is how the eruption of Mount Tokachi appears to me."

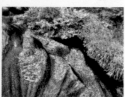
Yamagata, Japan, 1964

"Plants of little creek."

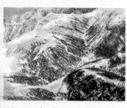
Toyama, Japan, 1964

"Through the Kenryuzan Mountain to the Ushiro Tateyama Mountain, there are very sharp rocks that rise up to the heavens; and just in-between, there is a very deep valley. There is also a very steep incline from the top to the bottom of these mountains."

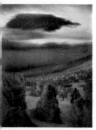

Mount Zao, Japan, 1964

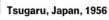
Tsugaru, Japan, 1956

"A woman hurrying on the snow road—the weather in this northernmost part of Japan is very severe, and the normal means of transportation are not usable. That's why the people must do a great deal of walking."

Donald McCullin

Chronology

1935
Born in London, England

1940
Evacuated from London as result of bombings

1948
Trade Arts Scholarship for painting to
Hammersmith School of Arts and Crafts

1950
Father died, relinquished scholarship and left
school

1953
Joined RAF; in Egypt, made photographic
assistant working in aerial reconnaissance
printing; spent duty also in East Africa and
Cyprus; bought first camera, Rolleicord

1955
Returned to England

1961
Photographed building of Berlin Wall; pictures
bought by THE OBSERVER (London)

1962–1964
Photographed English social problems

1964
On assignment in Cyprus, began career as war
photographer; for this coverage was awarded
World Press Photographer Award and The
Warsaw Gold Medal; joined LONDON SUNDAY
TIMES

1967
Covered conflict in Congo

1968
Covered Tet offensive, South Vietnam

1970
Covered conflict in Cambodia

1970–1971
Covered civil war in Biafra

1971
Covered Indian-Pakistani war

1971
Covered civil war in Northern Ireland

1972
Further coverage of Indochina conflict

Exhibitions

1972
*Four Internationally Famous Magazine
Photographers,* photokina, Cologne, Germany

Books

THE DESTRUCTION BUSINESS, London,
The Macmillan Company, 1971

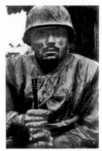

Hue, South Vietnam. 1968

"Most of the battalion were killed or wounded. Some companies
were so badly shattered in numbers that there were only about a
half dozen men in one company. I think what happens is that one
goes over the edge—you become slightly mad. I lived like an ani-
mal. I didn't wash. I ate what I could. I slept where I could. I
sponged food off of soldiers who were only too pleased to give
it to you to start up a fresh conversation. And I started becoming
much more akin to the soldiers."

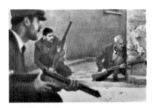

Cyprus, 1964

"What happened was that 5,000 Greek irregulars had surrounded
the Turkish community and were then proceeding to annihilate
everybody in it. I was in the middle of an engagement that was to
last for four solid days of hand-to-hand street fighting."

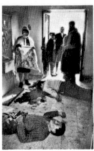

Cyprus, 1964

"A man came down and said, 'There's a dead man up there,' and
I thought, 'Well, this is it. I'm going to see my first dead man now.'
I always thought that if you see a dead man he's going to sit up
and embrace you or something, you know, I was so terrified. And
then I realized that this man wasn't going to hurt me. He wasn't
going to do anything. He was dead and he could just as well have
been a tree that had been felled."

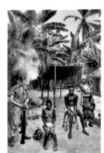

Congo, 1967

"This is the difference between White Africa and Black Africa—
the whites have always had the guns...."

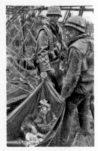

Hue, South Vietnam, 1968

"This vietcong soldier had been lying in a bunker for three days and had been fished out by a medic who was trying to decide what to do with him....A lot of the other soldiers couldn't have cared less about him—they thought it a better idea to put a .45 bullet in his head."

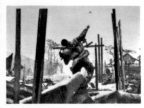

Hue, South Vietnam, 1968

"I photographed a marvelous colored guy throwing a grenade. He looked like a kind of Greek javelin thrower, you know. A grenade came out and blew his hand to pieces. One minute he was a great giant athlete and the next minute there was a great stump where once a hand had been. I could see him crying with his eyes all burnt and weeping, and another Negro saying, 'You're stateside—you've got no problem—stateside.'"

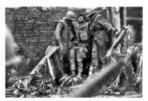

Hue, South Vietnam, 1968

"It was my first baptism of war—all-out war because I'd been doing Mediterranean street fighting and things like that. This was none of that back-street stuff. This was the real stuff."

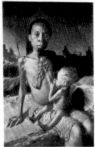

Biafra, 1969

"I found a woman feeding her baby from the breast and the baby was wasting his time...the breasts were old and empty."

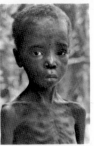

Biafra, 1970

"The very last day I was in Biafra I walked into a camp and saw eight hundred children standing on their legs, dying of starvation. I actually saw a child drop dead and carried in for an emergency operation to save its life by pumping adrenalin into his throat down to its heart. The whole thing was a drama which, in a way, was pointless because the child would only have been resuscitated to face the same problem again of trying to survive. It's very easy to make great pictures of this kind of situation, but who needs great pictures when somebody's dying? Who needs great pictures? We don't need great pictures. We need something very quick to understand that we as human beings are not permitted to allow this."

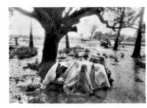

Bangladesh, 1971

"Lashed by a sudden onset of the monsoon, refugees sought shelter beneath plastic strips or banana leaves. Children, shivering at the drop in temperature, put plates on their heads; mothers drew their saris 'round their babies, as though it would really help."

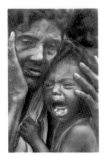

Bangladesh, 1971

"West Bengal is filled with the sound of crying children. The child has its mother to soothe it, but it is perpetually hungry, bewildered, and frightened; and both are an easy prey to exhaustion and disease. Ceaseless rains bring danger of bronchial pneumonia, which by that July had succeeded cholera and starvation as the biggest threat to survival; meanwhile the swelling of the stagnant pools by floodwater breeds bacteria."

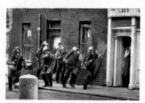

Derry, Northern Ireland, 1971

"Ever since the Great Siege of 1689, Londonderry has been a focal point for Northern Ireland's turbulent history; and it is there that the present complex crisis can be seen in all its tragic intensity. Here, dismayed housewives watch from their Georgian doorways as soldiers of the Royal Anglian Regiment—dressed for battle like Samurai warriors—charge down William Street after an outbreak of stoning."

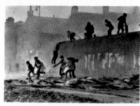

Derry, Northern Ireland, 1971

"Londonderry Catholic youths are escaping over a wall from an attack of CS gas in a burnt-out sorting office at the Little Diamond. Some now have a slight immunity to the gas and taunt the soldiers, 'Give us more, it makes our hair grow!' There is a joke going around that the Bogside crisis is producing Olympic athletes."

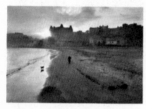

Yorkshire, England, 1968

"I don't want to die for a few pictures. I want to live for every sunrise I can clap my eyes on; I want to see my family get older; I want to see the world try and get a bit more peaceful and understanding, which unfortunately I don't think I'll ever see. The trouble is that here we are entering our kind of eighth war and is anybody taking any notice?"

Hertfordshire, England, 1971

"I haven't got very much longer to go at being a war photographer. I mean the chips are down already. The signs are pretty bad already. I made a small scratch on the earth's surface as a war photographer...a very small one. I can make a bigger one by being killed. By that, I mean my pictures will probably be enhanced a bit more by it, if you understand. But, of course, all that is in the hands of fate, and I believe in fate."

W. Eugene Smith

Books

W. EUGENE SMITH, New York,
Aperture Monograph, 1969

Exhibitions

1955
The Family of Man, Museum of Modern Art,
New York

1957
One-man show, *Ten Buildings in America's Future,* National Gallery of Art, Washington, D. C.

1971
One-man show, *Let Truth Be the Prejudice,* sponsored by the International Fund for Concerned Photography, Jewish Museum, New York

Chronology

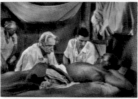

Dr. Albert Schweitzer, 1954

"LIFE magazine had marked him in quotes as 'the greatest man in the world,' which is a terrible, terrible burden to put upon any man. He was a giant of a man cursed with mortality and that legend; and he was his own man. I regret that too many smaller minds have come to conclusions of him that are quite far away from him. I once asked one of the patients, who had been rather severely criticized by Schweitzer, how the man really evaluated Schweitzer. And the man said, 'Who else has come to cure us?' "

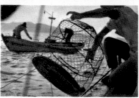
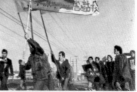
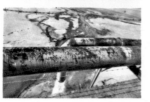
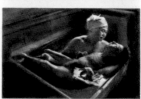

Minamata, Japan. 1972

"Minamata is both a fishing village and a one-company industrial city in the Kyushu district of Japan. It is also the basic setting for a historic confrontation: the victims of Minamata disease vs. the Chisso Corporation, a company officially declared by the government as having caused the disease through pollution.

"A first recognition in 1953 of 'something of a deadly disease,' which in 1972 is being bitterly fought in the courts, and which also is being fought outside of the courts (sometimes in the streets) by newly verified victims is a legal situation not easily made clear. It is not a question of whether the company is guilty, but the quality of that guilt in determining how much compensation should be paid the victims and the families of victims. The court trial is to determine whether Chisso knowingly continued to discharge poisonous wastes.

"At present there are 181 officially declared Minamata disease patients. Fifty-two victims have died. The disease was caused by methyl mercury compound toxication, and the source of the organic mercury was the effluent from the acetaldehyde plant at the Chisso factory.

"What is of greater significance is that although only 181 have shown officially verified symptoms, hundreds of thousands living in towns and cities throughout the area were eating affected fish and to some extent accumulating methyl mercury in themselves during this period. Symptoms of the disease have occurred clear across the huge bay quite far from Minamata itself.

"The responsibilities of morality, legality, and humanity....

"The possible and the just—the mentality of those who fight the power fights of our existence. Jun Ui—a Japanese catalyst to this struggle against pollution—has written a thick book which he doubts will ever be very much read. He says he has written it without any hopeful prospects. He says that he must continue his fight as the Minamata patients did—without prospects. He says that at the worst, after a vanishing of humanity, maybe in a thousand years cockroaches or other life that may be existent will read that book and learn not to do as the human race did."

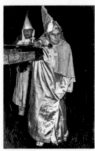

U.S.A., 1953

Dear —— (an editor):

P.S. In printing the photographs of the white-gowned Klan members I ran into considerable difficulty. There were several with uncovered faces, and these faces were so vividly dark in comparison to the white-white of the gowns that it was almost impossible to keep them from appearing black.

I'm terribly sorry."

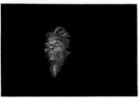

Haiti, 1959

"One picture from a photographic essay on a Haitian mental clinic."

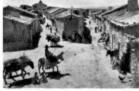

Spain, 1951

"Away from the publicized historical attractions, away from the unrepresentative disproportion of the main cities, away from the tourist landmarks, Spain is to be found. Spain is of its villages, simple down to the poverty line, its people unlazy in slow-paced striving to earn a frugal living from the ungenerous soil. Centuries of the blight of neglect, of exploitation, of the present intense domination weigh heavily; yet the people are not defeated. Believing in life, they reluctantly relinquish their dead.

"I had the opportunity to go to Spain and photograph there. This Spanish village is not one of the magnificently whitewashed ones that we so frequently see. Yet there is pride, and perhaps there is also a conditioned tendency toward cruelty."

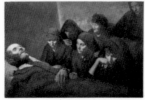

Spain, 1951

"In photographing the dead man and the mourners I did not want to invade the privacy of the moment, yet I could see from the outside that it was a very moving and even beautiful moment. Finally, I approached the son who had come to the door and asked him if I could enter for a few moments and photograph. He said that he would be honored."

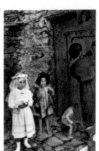

Spain, 1951

"The Spaniards are a people who are not easily defeated. They work the day and sleep the night, struggle for and bake their bread—and believe in life...."

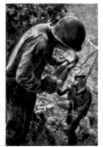

Saipan, 1944

"This baby was found with its head under a rock. Its head was lopsided and its eyes were masses of pus. Unfortunately, it was alive. We hoped that it would die."

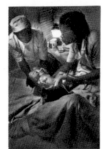

South Carolina, 1953

"This essay on the nurse-midwife, Maude Callen, is in many ways the most rewarding experience photography has allowed me. At the time of the essay, she bore almost total responsibility for several thousand scattered, swampbound, backwoods individuals. They are better off for her care, and I certainly know that I am a better person for her influence. And, if that sounds like a love letter...it is."

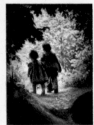

U.S.A., 1946

"These two children are my children. On my thirteenth invasion, I was severely wounded, and two and a half years later, after more than thirty operations, I did not know whether I was going to be able to continue as a photographer. And the day I again tried for the first time to make a photograph, I could barely load the roll of film into the camera. Yet I was determined that that first photograph would contrast to the war photographs and that it would speak an affirmation of life."

icp

THE INTERNATIONAL FUND FOR CONCERNED PHOTOGRAPHY

Exhibitions

1967

The Concerned Photographer, six one-man shows by Werner Bischof, Robert Capa, Leonard Freed, André Kertész, David Seymour ("Chim"), and Dan Weiner, Riverside Museum, New York

1968

The Concerned Photographer (second edition), Tokyo followed by eight-month tour of principal cities of Japan

Eyewitness: Czechoslovakia, work by Jan Lukas, Hilmar Pabel, Sonja Bullaty, and Angelo Lomeo dealing with that nation from the Nazi invasion in 1938 through the upheaval of August 21, 1968, Riverside Museum, New York

Typically American—Photographs by Burk Uzzle, Riverside Museum, New York

1969

The Concerned Photographer (first edition), Smithsonian Institution, Washington, D. C. The State University of New York at Albany (tour throughout U.S.A. under joint auspices of Smithsonian Institution Traveling Exhibition Service and ICP)

The Concerned Photographer (second edition), Triennale, Milan, Italy; Israel Museum, Jerusalem, Israel

Lewis W. Hine: A Concerned Photographer, Riverside Museum, New York (in cooperation with the Museum and George Eastman House)

America in Crisis, Riverside Museum, New York (in cooperation with the Museum and Magnum Photos, Inc.)

1970

The Concerned Photographer (first edition— continued U.S. tour under joint auspices of Smithsonian Institution Traveling Exhibition Service and ICP), Philadelphia Civic Center, Pennsylvania; Erie County Savings Bank, Buffalo, New York; Federal Deposit Insurance Corp., Washington, D. C.; Hopkins Center, Dartmouth College, Hanover, New Hampshire; California Museum of Art, Santa Barbara; University of Southern California Gallery, Los Angeles, California; Oklahoma Art Center, Oklahoma City

The Concerned Photographer (second edition), Israel Museum, Jerusalem, Israel; Palazzo Dei Diamanti, Ferrara, Italy; Museo d'Arte Moderna, Torino, Italy; Centre Le Corbusier, Zurich, Switzerland

Lewis W. Hine: A Concerned Photographer, became part of second edition of *The Concerned Photographer*

America in Crisis, SICOF (Italian Cine-Photo-Optics Show), Milan, Italy

1971

The Concerned Photographer (first edition— continued tour of U.S. under joint auspices of the Smithsonian Institution Traveling Exhibition Service and ICP)

The Concerned Photographer (second edition— continued tour of Europe under auspices of ICP)

Let Truth Be the Prejudice, five-hundred-print retrospective of the work of W. Eugene Smith, The Jewish Museum, New York; Tokyo, followed by tour of principal cities of Japan

The Concerns of Roman Vishniac: Man, Nature and Science, first comprehensive exhibition of the photographer's work in both color and black and white still photographs, including a slide presentation narrated by Dr. Vishniac entitled *The Life That Disappeared: The Vanished World of the Shtetl,* and a multimedia presentation on Dr. Vishniac at work entitled *Roman's Legions,* The Jewish Museum, New York (made possible in part by grants from The New York State Council on the Arts and The Joe and Emily Lowe Foundation)

Images of Concern, group show of work by more than eighty photographers who have collaborated with ICP on its various projects and/or are represented in ICP's permanent print collection, Neikrug Galleries, New York

1972

The Concerns of Roman Vishniac, The State University of New York at Albany touring U.S. under auspices of ICP

Images of Concern, Focus Gallery, San Francisco; Monmouth Museum, Red Bank, New Jersey; Bienville Gallery, New Orleans

Behind the Great Wall: an Exhibition of Photographs of China from 1870 to the Present, including photographs by René Burri, Robert Capa, Henri Cartier-Bresson, and Marc Riboud; Cornell Capa, guest director of the exhibit for The Metropolitan Museum of Art, New York. The exhibit will be circulated throughout the world under the auspices of ICP in collaboration with the International Exhibition Service, Washington, D. C.

Books

DAVID SEYMOUR—"CHIM" (a monograph), edited by Cornell Capa and Sam Holmes with introduction by Judith Friedberg, New York, Paragraphic Books division of Grossman Publishers, Inc., 1966

WERNER BISCHOF (a monograph), edited by René Burri and Rosellina Burri Bischof, New York, Paragraphic Books division of Grossman Publishers, Inc., 1966

ANDRÉ KERTÉSZ (a monograph), adapted for the American edition by Robert Sagalyn with introduction by Anna Farova, New York, Paragraphic Books division of Grossman Publishers, Inc., 1967

THE CONCERNED PHOTOGRAPHER, the photographs of Werner Bischof, Robert Capa, Leonard Freed, André Kertész, David Seymour ("Chim"), and Dan Weiner, edited by Cornell Capa, New York, Grossman Publishers, Inc., 1968

ROBERT CAPA (a monograph), Anna Farova, editor; Cornell Capa and Sam Holmes, associate editors, New York, Paragraphic Book division of Grossman Publishers, Inc., 1969

THE CONCERNED PHOTOGRAPHER 2, the photographs of Bruce Davidson, Ernst Haas, Hiroshi Hamaya, Donald McCullin, Gordon Parks, Marc Riboud, W. Eugene Smith, and Roman Vishniac, edited by Cornell Capa and Michael Edelson, New York, Grossman Publishers, 1972

Articles

1967

POPULAR PHOTOGRAPHY, September issue, portfolio from *The Concerned Photographer* exhibit

INFINITY, October issue, portfolio from *The Concerned Photographer* exhibit with text by Cornell Capa

PRINT, October issue, portfolio from *The Concerned Photographer* exhibit

1968

CORONET, January issue, portfolio from *The Concerned Photographer* exhibit

LIFE INTERNATIONAL (Asia edition), portfolio from *The Concerned Photographer* exhibit

1969

CAMERA, Lucerne, Switzerland, published in English, French, and German editions, complete issue devoted to ICP and *The Concerned Photographer* exhibit and book

CONTEMPORARY PHOTOGRAPHER, complete issue devoted to ICP and *The Concerned Photographer* exhibit, with articles by Frank Gibney, Carl Chiarenza, Donald Underwood, and Cornell Capa

POPULAR PHOTOGRAPHY ITALIANA, Milan, Italy, issue devoted to ICP and *The Concerned Photographer* exhibit

1970

INFINITY, July issue, complete issue devoted to ICP and *The Concerned Photographer* and *The Concerned Photographer II* lecture series

1971

POPULAR PHOTOGRAPHY ITALIANA, Milan, Italy, January issue devoted to ICP and its activities, including a portfolio from *America in Crisis* exhibit

CREATIVE CAMERA, Great Britain, March issue devoted to ICP and its activities

INFINITY, July issue, portfolio by W. Eugene Smith from *Let Truth Be the Prejudice* exhibit

INFINITY, October issue, portfolio by Dr. Roman Vishniac from *The Concerns of Roman Vishniac* exhibit with text by Michael Edelson

POPULAR PHOTOGRAPHY, July issue, article on The Concerns of Photography workshop presented by ICP in cooperation with The Center of the Eye in Aspen, Colorado

Catalogues

THE CONCERNED PHOTOGRAPHER (in connection with Riverside Museum exhibit), New York, 1967

THE CONCERNED PHOTOGRAPHER, Japanese text (in connection with showings in Japan), 1968

THE CONCERNED PHOTOGRAPHER, text in Italian, German, and French (in connection with European tour of the exhibit), 1969

THE CONCERNED PHOTOGRAPHER, Hebrew text (in connection with showing at Israel Museum, Jerusalem, Israel), 1969

THE CONCERNS OF ROMAN VISHNIAC, New York, 1971

Education

1969

The Concerned Photographer series of lectures in cooperation with New York University School of Continuing Education; speakers included: Diane Arbus, Cornell Capa, Benedict J. Fernandez, Robert Fitch, Leonard Freed, Ernst Haas, Charles Harbutt, Ken Heyman, Marc Riboud, and Dr. Roman Vishniac

The Concerned Photographer II series of lectures in cooperation with New York University School of Continuing Education; speakers included: Cornell Capa, Bruce Davidson, Douglas Faulkner, Paul Fusco, Jan Lukas, John Launois, Donald McCullin, Arthur Rothstein, Michael Semak, W. Eugene Smith, and a multispeaker session with Herb Goro, Dennis Stock, Sandra Weiner, Marc Riboud, Peter Pollack, and Richard Grossman

The Concerns of Photography month-long workshop in cooperation with The Center of the Eye in Aspen, Colorado, directed by Sam Holmes and Cornell Capa with one-week lectures by Bruce Davidson, Dr. Roman Vishniac, Willard Van Dyke, Allan King, and Peter Pollack; and special guest speakers Ruth Bernhard, Patricia Caulfield, Sandra Weiner, John G. Morris, and Benedict J. Fernandez

1971

The Concerned Photographer III series of lectures in cooperation with New York University School of Continuing Education; speakers included: Eliot Porter, Ruth Bernhard, Bhupendra Karia, György Kepes, Robert Frank, Walker Evans, Martin Schneider, Rollie McKenna, Roman Vishniac, Eddie Adams, Mark Jury, and Ron Haberle on Vietnam—a Photographic Summary, and Tim Kantor, Dan Nelken, Nancy Sirkis and Sandra Weiner on Social Exploration in Books and Film. An expanded program included, in addition, master classes of eight sessions each by Ruth Bernhard, Arthur Rothstein, and Roman Vishniac, and a weekly Seminar/Critique class with the guest speakers of the lecture series.

1972

The Concerned Photographer IV series of lectures in cooperation with New York University School of Continuing Education; speakers included: Herb Goro, Marc Riboud and René Burri, Michael Abramson and Andre Lopez, Josef Breitenbach, Jill Freedman and Jill Krementz, George Gardner and Charles Gatewood, Chester Higgins, Jr., Jerry Uelsmann, Ralph Gibson, Danny Seymour and Neal Slavin, Cole Weston Larry Clark. An expanded program included, in addition, master classes of eight sessions each by Erich Hartmann and Arnold Skolnick, Andreas Feininger, and Herb Goro, and a weekly Seminar/Critique class with the guest speakers of the lecture series.

The Concerned Photographer V series of lectures in cooperation with New York University School of Continuing Education; speakers included: Berenice Abbott, Fred McDarrah, Roy De Carava, Duane Michals, Flip Schulke, Alfred Eisenstaedt, Constantine Manos, Lee Friedlander, Leslie Krims, and Arthur Tress, plus work/study classes of eight sessions each by Arnold Skolnick, Herb Goro, and Bill Pierce.

Images of Man audiovisual library series produced in collaboration with Scholastic Magazines, Inc., consisting of four narrated filmstrips with teaching guide and portable exhibit of forty photographs on the work of Bruce Davidson, Donald McCullin, W. Eugene Smith, and Cornell Capa.

About ICP

The International Fund for Concerned Photography, Inc., was born out of a respect for the images of the past, anxiety for the photographic direction of the present, and concern about the existence of true documentation of the future:

1. To promote and sponsor the use of photography as a medium for revealing the human condition, commenting on the events of our time, and improving understanding among people.
2. To assist photographers regardless of age or nationality, whose work shows personal commitment, through grants and purchase awards.
3. To rescue from oblivion many notable and historically important photographs, and to present this work to the public through an active program of exhibitions, books, periodicals, film, television, and other visual media.
4. To work with existing cultural and academic institutions in order to establish a major resource for the exchange of information on important photographic work and allow greater accessibility of such work to the public.
5. To establish a world-wide network of autonomous national affiliates of the Fund, each with its own museum and national program supported by public-spirited people who, in turn, are vitally interested in the preservation and creation of the visual documents of their own history and culture.

The Board of Trustees and Advisory Council of ICP are drawn from many intellectual disciplines, but all are involved in the visual perception of the world and work closely with "concerned photography," both to identify talent and ideas and to indicate the direction and the level of quality of photographic exhibits. Included among the Council are photographers, film-makers, educators, museum curators, art historians, psychologists, architects, writers, and journalists who share a concern with man and his world.

Established in 1966 in memory of Werner Bischof, Robert Capa, and David Seymour ("Chim"), the Fund seeks to encourage and assist photographers of all ages and nationalities who are vitally concerned with their world and times. It aims not only to find and help new talents, but also to uncover and preserve forgotten archives and to present such work to the public. The International Fund for Concerned Photography is a non-profit educational organization; contributions are deductible for income, gift or estate tax purposes in accordance with federal and state tax laws.

Cornell Capa, Executive Director
International Fund for Concerned
Photography, Inc.
275 Fifth Avenue
New York, N.Y. 10016

This book is set in Permanent
by TypoGraphics Communications, Inc., New York City
Printed by Etablissements Braun & Cie., Mulhouse-Dornach, France

Designed by Arnold Skolnick